GENTLE CHAOS
POEMS, TALES, AND MAGIC

GENTLE CHAOS
POEMS, TALES, AND MAGIC

TYLER GACA

RUNNING PRESS
PHILADELPHIA

Running Press
Hachette Book Group
1290 Avenue of the Americas, New York, NY 10104
www.runningpress.com
@Running_Press

Printed in China

First Edition: October 2023

Published by Running Press, an imprint of Perseus Books, LLC, a subsidiary of
Hachette Book Group, Inc. The Running Press name and logo are trademarks
of the Hachette Book Group.

The Hachette Speakers Bureau provides a wide range of authors for speaking
events. To find out more, go to www.hachettespeakersbureau.com or email
HachetteSpeakers@hbgusa.com.

Running Press books may be purchased in bulk for business, educational, or
promotional use. For more information, please contact your local bookseller or the
Hachette Book Group Special Markets Department at Special.Markets@hbgusa.com.

Print book cover and interior design by Jenna McBride.

ISBNs: 978-0-7624-8204-7 (hardcover), 978-0-7624-8205-4 (ebook)

APS

10 9 8 7 6 5 4 3 2 1

FOR YOU.

This book is dedicated to those who
never quite felt like they belong.

To my husband.

To all the women in my life.

To the kids who both loved and feared
the spotlight, and were too busy making
up their own games to play with others.

To those who create magic.

To family both blood related and chosen.

To those who were scared of everything as a
child and now seek comfort in Halloween.

THIS BOOK IS FOR ME,
JUST AS MUCH AS IT IS FOR YOU.

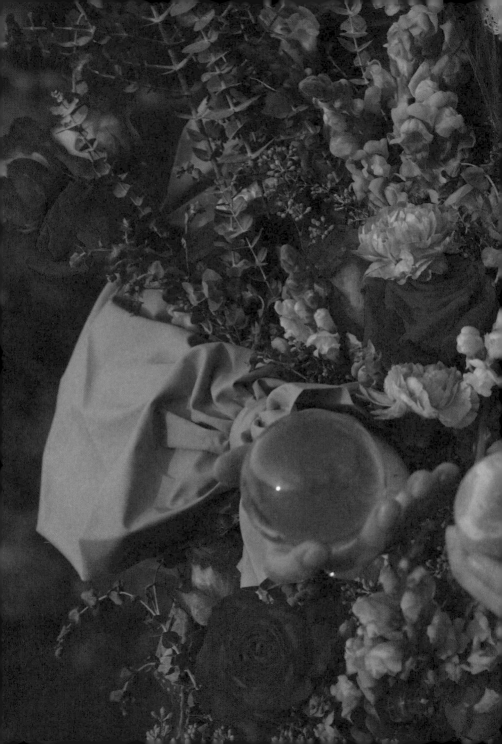

CONTENTS

:::

Introduction **ix**

PART 1
IN THE OKLAHOMA SUN **1**

PART 2
THE FOOL IN THE MOUNTAINS **37**

PART 3
ON QUEERNESS AND MAGIC **65**

PART 4
GHOSTS AND HONEY **131**

PART 5
CURTAIN CALL **169**

Acknowledgments **229**

About the Author **230**

Introduction

Greetings! Thank you so much for picking up this copy of *Gentle Chaos*. This little book is filled to the brim with the types of emotions and secrets that sometimes feel too big for our bodies to contain. It is full of quiet moments of reflection, of love, joy, and sorrow.

My hope is that with this book, you find a moment of respite from the world around you and you are able to discover a piece of yourself in one of these poems, tales, or slivers of magic. There is true beauty in vulnerability, and there is magic in pouring your heart out for both others and yourself. What a delicious treat it has been to take these fragments of my life that have shaped me so much and thread them together into a grandiose display for you all.

I am so happy you are here.

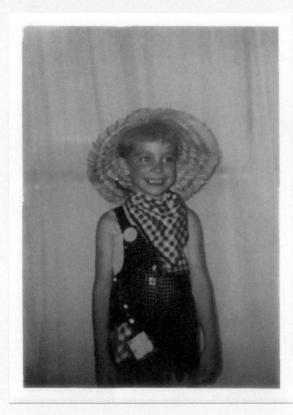

part 1

IN THE OKLAHOMA SUN

TINY DANCER

remember running around a wooden playground in Norman, Oklahoma, stopping occasionally to watch my grandmother, who was sitting on a bench nearby, carefully removing the lace trim from the sleeves of my dance recital costume. I was maybe five or six years old and the only boy in my combination ballet, tap, and jazz class. We had a recital coming up, and for one of the routines, for whatever reason, the school ordered me the same outfit as the girls: a yellow polyester top with frilly lace trim around the shoulders, a blue sequined overall dress with matching sequined patches, a gingham neckerchief, a straw hat, and a corncob pipe.

I don't remember being upset about matching with the girls, but I do remember listening as adults talked about the mix-up and suggested solutions to make the outfit a little more "masculine." Looking back now, it's comical to think removing the lace trim from the equation would make a blue sequined overall dress any less "feminine" or more acceptable for a boy to wear.

If anything, I was used to wearing dresses. Growing up with two older sisters, I always wanted to take part in whatever

they were doing. My options were often to play dolls and dress-up or not play at all, and that was never an issue for me.

When the night of the show came, I stood in the doorway of the bathroom watching my mom apply blush and mascara on my older sister, who was also in the recital, and excitedly asked for the same treatment. My mom never tried to dissuade or argue with me, and I remember how happy I felt as she applied makeup to my cheeks, too. The excitement and nerves that came with performing were thrilling to me at that age. Sometimes the night before a performance I would dream I was on the stage basking in the hot lights, moving through my routine as butterflies danced in my stomach along with me. I was madly in love with performing, but dance was my first love, and I had three large ballet books I swooned over every day. They contained photos of dancers from *Swan Lake* and *Coppelia*, the illustrations for their costume designs, and descriptions of how the acts of each show broke down the story. I would marvel over every detail—and I wanted so badly to grow up to be one of those strong, elegant men in tights.

My personal favorite was *The Nutcracker*, a ballet that I loved so much I needed to have the real thing for myself. By seven years old, I already had quite the collection: I would get nutcrackers for every birthday and Christmas gift. When we got a new dog, Nutcracker was my name suggestion (luckily, they went with Switzer, after the Oklahoma Sooners football coach). My mom even allowed me to hang nutcracker wallpaper in my room. We owned countless VHS versions of the ballet, and watching the stage production live for the first time, the way the Christmas tree swells and grows on stage and you as an audience

member seem to shrink alongside Clara was beyond enchanting for me. I was consumed with everything about that world: the magic, the stage production . . . even the Rat King, whom I feared, I also loved.

Yet I can pinpoint exactly when that love, born out of my passion for performing, turned into nerves and dread.

After I finished first grade, my family moved from Oklahoma to Virginia for my dad's job. I remember my parents asking, "How would you feel about moving?" And I remember replying, "It's fine with me!" I had no concept of the distance between Oklahoma and Virginia, or of the fact that moving means leaving your bedroom behind and saying goodbye to friends and family. I felt panicked the night before we left, sitting on the empty living room floor, eating a Subway ham-and-cheese sandwich because our kitchen was all packed up and crying to my mom because I finally understood that I wasn't going to see my childhood friend who lived in the house behind ours anymore.

When we got settled in the new place, my mom asked me if I wanted to keep dancing, and naturally I did. But when I walked into my new ballet class on the first day and looked around, I realized I didn't know these kids or these teachers. My former dance teacher was a kind older woman who lined us up at the end of every class and gave us each one stale gummy bear that she handed out with tweezers from a metal tin box she kept in the classroom. In this new place, I sat on the floor with the other students as we did our stretches and was suddenly overwhelmed with the realization not only that I did not know these people at all but also that I was the only boy once again.

This had never bothered me before—I loved being the only boy in my other dance troupe. It meant that I was almost always guaranteed a solo of some sort, like the part of Hansel in *Hansel and Gretel*, or a position center stage for symmetry purposes. But as I sat on this new, unfamiliar floor doing a butterfly stretch, surrounded only by girls, I began to cry. Hyperaware of myself and my new surroundings. Hyperaware that I was different and new and standing out in a way I didn't like. In that moment I could feel myself shrinking and retreating from the other kids around me. There was no exterior force telling me I was wrong and stood out. I am not sure if in that moment it was just the new location that brought on those realizations or something I had internalized from old conversations about my recital outfit. But I wanted nothing more than to hide, to become invisible. I never returned to that dance class.

I wish I could say that I was bold and brave and danced anyway. But for years, I was, like so many other kids, just so scared of standing out. I always wondered how different my life would have been if I had stayed in Oklahoma and stuck with dance. Would I still have pursued painting and drawing? Would I have eventually given up dance anyway, like I did piano lessons? Or karate? Or fencing? I always loved the spotlight, and that love never faded, but as I got older, I started to fear it just as much. When I look back at my life, I see so many moments when fear paralyzed me, even at a young age.

In sixth grade, I got a small solo in my choir class's winter show. I practiced my line over and over. "Glories stream from heaven above. Heavenly hosts sing Hallelujah." This was middle

school. The eighth graders seemed so much bigger and so much older than any kids I had known. The stakes felt so much higher. To stand out in this environment was even more of a detriment to your own safety and overall experience.

During the show, I delivered my lines and felt a rush of excitement and relief that my voice didn't crack. That even though I was scared and shaking, I managed to remember the words. But when the next girl went up to sing her solo, the next line of "Silent Night," she froze. Nothing came out. The rest of the choir came together in the moment and shakily sang the lines to fill in what must have been a chilling silence for her. In a way, it was sweet. But I remember standing next to her while we finished the last of our holiday songs as tears streamed down her face in my peripheral vision. We walked off stage, and when my parents found me in the hallway outside of the choir room, I burst into tears too. I'm not sure why. Maybe from a combination of nerves and empathy for that girl.

We performed the song once more, this time for the whole school during an assembly, and everything went well. Afterward, a girl passed me in the hall and said, "You were great! You didn't even sound like a boy! You sounded like a girl!" and I thought, *Great. I am never going to sing again.* The comment wasn't harsh and didn't even come from a place of ill intent. But once again, in that moment, I felt that icy panic and need to retreat. I wanted nothing more than to shrink down inside myself and disappear. I didn't want to stand out; I didn't want to be different; I didn't want to be seen at all anymore. I think I was so critically aware of my own internal differences that the safest idea

at the time was to cast away any outward passion or interest that would set me apart. I was afraid that if I stood in the spotlight for too long, someone would be able to sniff out the secret feelings I was battling internally every day.

With dancing and singing now off the table, drawing and painting became the only constants in my life. Visual art was something I could do in isolation. And crucially, being good at art never made me feel shy or nervous. My passion for art had been there alongside every other fleeting fancy, and when my love for ballet and singing and piano fizzled out, the flame I held for art steadily grew alongside and within me.

At twenty-four, I decided to start posting comedic videos on the internet after fantasizing for years about the idea. Even though I was recording alone in my home, I found that I often felt like the seven-year-old version of myself in that new dance class for the first time, or the eleven-year-old version of myself singing in the middle school gym with my high-pitched voice. I would shake and have a hard time even talking into the camera. It took a few months for me to calm down and escape the residual fear of standing out, of being different, of being perceived at all.

It's wild to think that only a few years later, although I'm not dancing, or singing, or on the stage, I am performing unapologetically again. One recent Christmas, my aunt asked me whether I remembered all the shows I used to perform for the family. How I would stand off stage, outside the living room, to gather myself, and then emerge from behind a sheet and force my family to watch a fully improvised show with multiple acts. It was one of those "a-ha" moments. I have no memories whatsoever of

putting on those performances as a kid, but at twenty-seven years old I felt validated knowing that I was always who I am today.

These days, I am still standing off stage in my own living room and gathering myself before I make a little joke, this time for the audience that lives inside my phone. How surreal to have come full circle—to realize the passions I had for the performing arts never really burned out or faded at all, just ebbed and flowed and evolved with the years. Maybe they never even really ebbed. Maybe it was just that my nerves and fears were for a long time louder than my desires. Sometimes they still are.

It is so important to nurture your younger self and the young people that you love. To put blush on your excited son before his first recital and to comfort him when he is too scared to dance or sing anymore. For a nervous child, merely speaking aloud what you want can be as paralyzing as the fear you think you'll experience if all your dreams come true. We only have to listen and support and encourage. Dreams may shift and change over time—mine feel like they do every day—but it is never too late for dreams, old and new, to come true. I hope I don't jinx myself by saying I truly feel like I'm only at the beginning of finding myself and my path as an artist. And it feels so good to have put my tap shoes back on, so to speak.

Whatever it is that fills you with equal parts awe and nerves, fear and excitement, I hope you stare it down and go after it. Just as importantly, I hope you encourage your loved ones to do the same. In times when you feel too scared to continue or move forward, know that even if you can't feel it, there are people just off stage wishing the best for you. ᠺ

Norman, Oklahoma

Virginia Beach, Virginia

Huntington, West Virginia

THREE STATES, THREE HOMES, THIRD CHILD

It is so easy for me
to fall in love.
To find home
despite never knowing
where I am going.

Oklahoma,
you're too hot.
One day I'll find you again,
through the thunder
and the love
that feet stomping
through golden grass to 7-Eleven
could bring on summer nights.

in Virginia,
the sprawling fig tree
in our backyard
was sometimes all I had.
Virginia, my great-grandmother,
cricket-filled nights
just my sisters and I
and the ghost
Of my great-aunt Nellie
who watched me grow wild.

West Virginia
is one hazy spring day
There were deer that ate from my hands,
there were deer inked into my skin
and a velvet moon to sing me to sleep
through the guest bedroom window
when the attic that hid me
became too hot to handle.

I'm so wary
of the power of three.
My father, the sun, the sanctity
of my holy spirit.

I'm so wary
as the third child
born on the third of October
that began again
three times
in three new homes.

Sometimes I don't remember
much at all
except for what it means
to say goodbye
over and over
and over again.

NEPTUNE

t seven years old, at the beginning of the longest summer of my life, I saw the ocean for the first time. The memory plays back in my mind like this:

Fresh in town, fresh to the East Coast, from our move from Oklahoma. It is late at night. The sky is already black, but as a family we climb in the car and drive to the beach. My sisters and I, so excited to see the ocean. We walk past the warm lights of the restaurants, the bike lanes and streetlights, and I take off my shoes and run barefoot through the sand toward the water.

In the darkness I cannot see where she meets the sky or how far to each side of me she extends. It's like running arms open toward a giant, slumbering just out of sight in the darkness. Cool salt spray rushes over my body, I can hear the waves crashing, and for all I know at seven years old, the ocean is also the sky. She is monumental and bigger than me, and it should almost be terrifying but it isn't. There is only pure joy reflected off me onto the moon and in return onto the rippling ocean waters all around me.

SHIRLEY TEMPLE

hen I was a child, I worshiped every afternoon after day care, a firm devotee, at the Temple of Shirley Temple. She was one of my first religious experiences. There used to be a restaurant in Oklahoma City called The Vista. It was located on the sixth floor of a building downtown that seemed to my youthful mind like the tallest thing in the world. Once you walked inside, you took an elevator ride to the top floor and entered the restaurant. I can still smell it more than twenty years later. Cigarette smoke, hot oil, and French fries. The inside is a little blurry in my memories, but I can manage to recall the long, sticky tables that seemed very high up for five-year-old me. My most vivid recollections are of the food I would eat there: chicken tenders, French fries, and a Shirley Temple. (I remember even more clearly eating the leftover French fries and chicken tenders cold and stiff out of a white Styrofoam to-go container the next afternoon.) They had a coloring page menu that never changed, and I would ask for it every time, color in every space, do all of the puzzles (which I had fully memorized), and insist on taking it home when I was finished.

There was a waitress there who always served us, and everyone would joke that she was my girlfriend, which made me feel shy and a little uncomfortable. Sometimes there was also a magician who would come around to the tables and do close-up magic. One of his tricks involved a doll-sized guillotine that one brave volunteer would put their finger through. The tiny blade would fall and then the magician would raise it back up, revealing that the volunteer's finger was still fully intact. I remember crying hard during this trick. This wasn't magic. This was madness! I closed my eyes and examined our family friend's finger after the magician left. *Did it hurt? Why would you let a man do that to your finger? Why do they even let that guy in here? He's not a magician, he's a butcher at best.*

But more than anything, I remember the Shirley Temples. That drink was like the elixir of life to me. You couldn't find it at the store. I didn't know it was just Sprite and grenadine. It felt special, exclusive, and mystical. And somehow, as time wore on, this love and another related love became entangled in my mind. I'm still not sure how it happened. Did my love for the drink lead to my love for the star? Or did my love for the star lead to my love of the drink? All I know for sure is that during this same period in my childhood, I also adored the actress Shirley Temple so much that my mom used to bribe me with her movies on VHS.

It should be no shock to you by now that I was a sensitive child and did not like to leave the comforts and safety of the house. I would enter day care, sit on the floor, and cry until pickup time. I would stare at the doorway as parents and guardians came

in one by one and look at their feet, waiting until I saw my mom's white tennis shoes walk in. When this behavior didn't let up, my mom would make a bargain with me. If I could be brave at day care for the afternoon, I would be rewarded with a new Shirley Temple movie on VHS.

I loved them all dearly. As an aspiring young dancer, I viewed her as my biggest inspiration. She could sing and dance, commercials selling collections of her work played every night on TV, and she even had a drink named after her—and somehow, she was the same age that I was. *Anything is possible.*

I remember my grandmother taking me to an antique mall where she had seen a Shirley Temple porcelain doll for sale she thought I would like. Before we even went inside, I saw it on display in the window. The doll had a white dress with red polka dots, and I told my grandma not to get it for me because I did not like the style of dress for some reason that I can't recall. I wasn't just sensitive. I was extremely particular and had incredibly decisive taste.

Of course, now, when I look back as an adult, my heart breaks for young Shirley Temple. The more you read about what she had to go through, the more you realize how nightmarish her life truly was and how hungrily a nation gobbled up her cherubic persona as it was marketed to them. Franklin Roosevelt even declared, "As long as our country has Shirley Temple, we will be all right." That is a lot of pressure to put on a child.

Now I sit here putting these words onto the page, reflecting on Shirley Temple, on The Vista and what it must have been like the day they closed it down, and on Sprite and grenadine,

in a cozy cabin I rented in Lake Arrowhead, California. While researching the area, I discovered that Shirley Temple built a vacation home here. This is possibly the closest I've been to a real relic of hers—not the image of her that was sold to me but the real her—in my entire life. Did she retreat from the world here like I did to write this book? Did she drive down these winding roads at night worried about the sharp curves and wary of the long shadows her headlights cast from the tall, looming pine trees? Could she relax and let go here away from the dry heat and haze that shrouded the twinkling lights of Los Angeles?

How haunting it can be to learn about your heroes. The more you humanize them, the more you realize how much you have in common and how much you disagree. I'm not sure which is better. It's probably best to idolize no one, to see everyone as human. To protect your heart. But you can't explain that to a little boy in Oklahoma who loves to dance and misses his mom, and all of these years later, I still feel like I am him and he is me. The Vista is closed, I live about twenty minutes from Grauman's Chinese Theatre, where Shirley Temple's handprints are immortalized forever in cement, and drinking grenadine mixed with Sprite still feels like consuming the elixir of life. ᏩᎡ

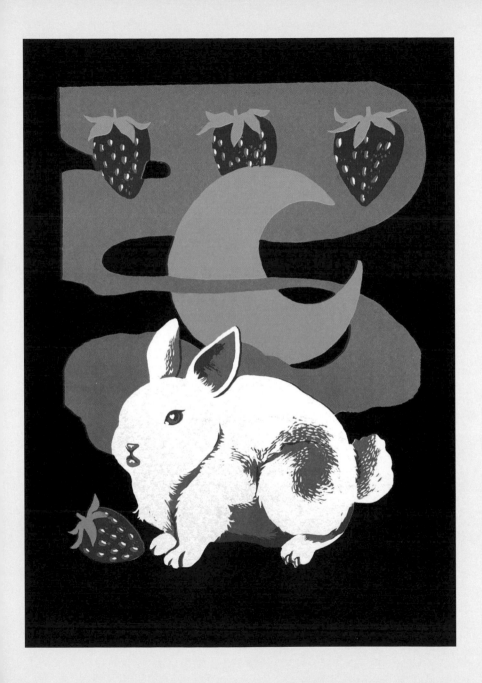

HALLOWEEN

s a quiet and nervous child, I put so much of my faith into magic. Into Halloween. I would spend hours by myself every day looking out windows and willing something out there deep in the cosmos to wake up and whisk me away in the wind, through a flower bush, through a broom closet. Everywhere I went, I looked for signs of it. I peeked under shelves in the grocery store, wondered whether it was waiting downstairs at night when I was too scared to leave my bed. I squeezed my eyes shut as tight as I could on my birthday, pictured this wish with all my might, imagined it as a golden light that illuminated my being from within. Starting in my chest, moving down my arms and torso to the tips of my fingers and toes and up my neck, it would shine through the skin on my face and travel down the length of every hair on my head. Then I would blow out my candles and imagine that golden light radiating through my breath. Hoping and hoping my wish would come true.

Halloween was the sweetest and saddest day of the year for me. I'm thankful to have spent the majority of them on the East Coast, where late October was full of leaves on fire cascading down into drifts alongside mountains of dried pine needles that

threatened to cover the streets entirely. Mist in the morning and fires from our small chiminea late at night. The scent of cinnamon, pumpkins, and apples. The little ceramic haunted houses my mom would set up around our home. The child-sized green witch with black feathers for hair that sat in a chair by the front door that I was too nervous to walk by at night. Rushing through the school day and running inside so I could finish my homework and put my costume on. Of course I was excited about the idea of free candy—what child wouldn't be? But I was equally thrilled by the prospect of endless possibilities. That on this night while the moon rose above my neighborhood and amber streetlights slowly flickered on, pint-sized witches and ghosts and zombies left their homes and trickled slowly through the roads. Maybe that night would be the start of something new. It could be the night my wishes would come true.

Maybe one of the streetlights would shine a little harder as I walked under it, beaming down on me from above, and it would hum and sparkle and flit me away to an identical neighborhood where real witches and ghosts roamed. They would teach me everything they know, and with a heavy heart I would say goodbye to the life that I knew and loved—though I wouldn't dwell on it for too long. I would humbly accept my fate and begin life anew enveloped in magic.

Unfortunately there comes a time though when the magic of the holiday seems to evade your grasp and slip away from those around you, no matter how tightly you try to hold onto it yourself. As the youngest child, there always comes the year when your older siblings don't want to trick or treat with

you anymore. While you're excited to still own the streets and feel the electric magic in the air, there's a heavy loneliness that comes with you that year. A knowledge that one day it will end for you, too.

For me, it was the Halloween when I was twelve, and my mom took me around the neighborhood instead. I was dressed as Ghostface that year. I had never seen *Scream*, and I thought he was just a fun, playful ghost with a face like the Edvard Munch painting. As I put my costume on and came down the stairs, my sister said something along the lines of, "Why is he dressed up like a serial killer?" My mom had never seen *Scream* either. My heart sank. I didn't want to be a murderer! Just a fun, playful ghost! So I took off the mask and pulled the hood over my head and told everyone I was a simple ghoul.

At one of the last houses of the evening, I rang the doorbell and a boy from my class answered the door. He wasn't in costume and was instead on candy duty, and I was mortified. The conversation went something like this:

"Oh, hey, Tyler…Happy Halloween." He appraised my black cloak.

"Oh, hey. Happy Halloween," I muttered back, overwhelmingly aware that we were the same age but he seemed so much older.

"What are you supposed to be?"

"Oh…I'm…a ghoul."

"Okay…," he said while dropping a piece of candy into my pillowcase. "See you later."

Devastating.

I walked back home that night feeling so sheepish and little. I think that was my last year of trick-or-treating. Which is silly! I'm sure if I had told my parents I still wanted to go the following year, they would have let me, but everybody goes trick-or-treating one last time at some point, and after the embarrassment of that experience, I couldn't bring myself to suggest it again.

As I get older, Halloween feels even more elusive. Always out of reach, gone before you've fully enjoyed its presence. November 1 will always fill me with a small twinge of sadness.

I have this recurring dream that summarizes my feelings toward Halloween perfectly: I am walking down the street of my former neighborhood with an old wooden broom in my hands. It is early in the morning, and there is a soft, cool blue light cast on the trees and the cars parked in the driveways. There are no sounds except for my footsteps. It is like the rest of the neighborhood is still asleep. There is that strange feeling in the air when nothing around you has necessarily changed but you're seeing everything that was once familiar in a different way, whether because of the time of day or season or state of mind.

I make my way down the street to the house where my best friend lived, exactly ten houses down from me. There is a ladder propped against her house, which was identical to my own but reversed in layout. I carefully climb it with my broom in hand and am giddy with excitement. This is it. This is the moment. I'm going to take flight. I clamber on to the rooftop and mount my broom and take a leap of faith. But instead of flying I float gently down to the ground. As if I'm slowly letting my breath out and allowing my body to sink to the bottom of a pool. I stretch

out my feet and they meet the grass gently. I think, *Dang it*. I did something wrong. Something is off. I need to try again.

I walk back over to the ladder, climb up with my broom and jump again. This time I pedal my legs in the air as if I'm on a bicycle. But I still return to the earth like a floating bubble, and my frantic pedaling only gains me a few additional feet of distance at most. I climb and jump and slowly coast back down over and over again. The dream is comforting, nostalgic, exhilarating, and disappointing all at once.

For a brief moment before I wake up, there are no other worries or responsibilities, everything is familiar and safe, but the atmosphere feels alive with magic. There is so much anticipation with every rung I travel up the ladder. *Maybe this time. Maybe this time.* If I pedal this way. If I take a running jump first. But the outcome is always the same.

It's not possible for me to accomplish what I want in that dream, but I can still do things there that I never would in real life. I am weightless. I am magic.

Halloween is the same. The climb to October 31 still fills me with excitement every year: for that month everything around me looks familiar, but the magic in the air casts it in a new light. I still get that *dang it* feeling when I wake up on November 1 and realize I wasn't spirited away to some unknown dimension in my sleep, but there is always a sentimental and sweet magic to the day that is impossible to recreate in any other way. ᘓᐢ

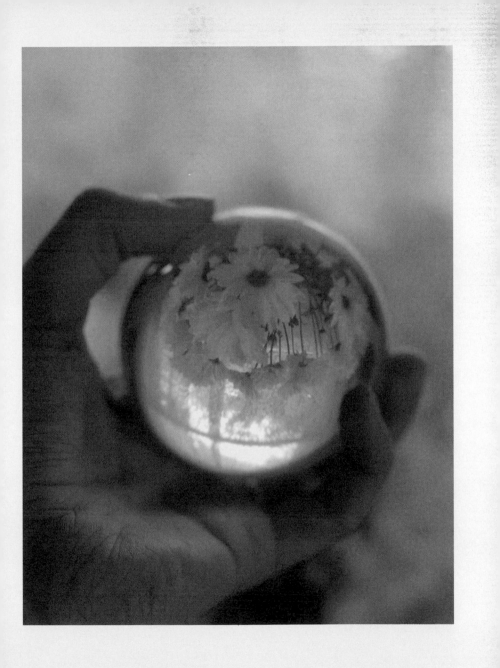

HERE LIES THE KING

Oh Lord
Here lies the king.
I'm nine years old,
it's a hot summer's day,
and I'm standing in front
of Elvis's grave.

for a moment in Graceland
Time stood still.

I may not have ever
felt so much
Or so religious
As I did taking in
the smell of the rooms
The feeling of my feet
Moving heavy
Through Tennessee heat

Wading through lush shag carpet.
Through the jungle room
sequined jumpsuits and capes,
Attending with strangers
a solemn ceremonious mass

Staring in reverence
At peacock stained glass

I cried
at the airbrush tattoos
My sister and dad both got
In the gift shop

So scared by the idea
of permanence.

To walk through a home
Turned museum

To be entombed
By the pool
And frozen in time
To have your name
Shown only ever in lights

Oh Lord
Oh my king
I am on my knees asking
Why, oh why, oh why
Can't my dream come true?

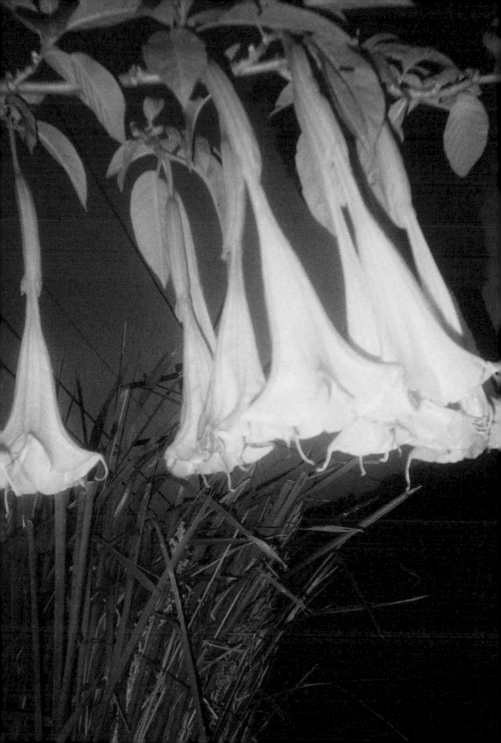

For Oscar,
His unnamed wife
This unnamed fish
I mourn all three
But in her faded smile
I feel joy in my ribs
And the clover under my feet
And I hope they were happy
And I hope they were loved

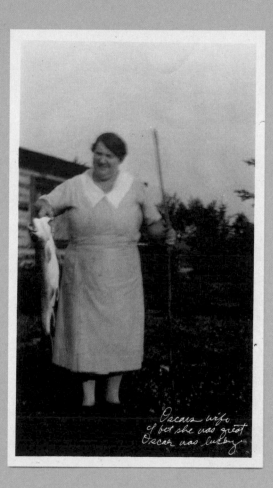

Oscars wife.
I bet she was great
Oscar was lucky

Like the sun
that burned
the shadows of these moths

onto this page

maybe I too

burned a little
of myself

into this book.

And in return

gave the ghost
of myself

over to you.

PAR MO CHIMINAY
(BUY OUR LEMONADE)

"Video Games"
in the back of the van
I drove for eight hours
just to take you to dance

My sister down the street
I called you my cousin

We ate spaghetti on walks
We both couldn't drive
got high off of laughter
And ran for our lives
From the ghosts of neighbors
Who had suddenly died

Ten years together
Ten houses apart
I had my first drink
In a tent in your yard
But even that night
You were already too far

away from the girl
that I knew growing up
To be so young
To have been through so much

All I want is to walk
And take a long time
to say goodbye to you
At the stop sign
That always served
as our divide

Running home barefoot
Try not to look back
you grew so wild
and I grew so sad

I think it's strange
I haven't met your kid yet
And now one's become two
I hope they grow up

and feel the same way
That we did for each other
I wonder if you
still talk to your mother,

How many secrets
we'll take to the grave
And just so you know
If I saw you today
After all of this time
I'd still meet you halfway.

part 2

THE FOOL IN
THE MOUNTAINS

BIRTHDAY BLUES

n my tenth birthday, I hopped off the school bus and ran home, my feet crunching on pine needles, yellow leaves, and helicopter seeds. My heart fluttered as I saw a gift bag and balloons on the dining room table. Sticking out of the bag was a purple skateboard with a handle that could be raised or lowered, transforming it into a scooter. Because it was mostly sticking out of the bag, my mom said I didn't have to wait until after dinner to open it. I took it outside and slowly kicked myself around in circles up and down the driveway. As I glided on the concrete, my heart started to feel heavy and anxious with every push.

I walked the scooter onto the front lawn and stared up at the giant oak tree that stood in the center. As I watched late afternoon sunlight dance through the leaves, a thought started racing in my mind: *I am ten years old. Double digits.* My childhood was effectively over. Before I knew it, hot and heavy tears started to well and overflow from my eyes. I slowly walked the scooter to the front door and propped it against the brick of our house.

I headed upstairs, tears clouding my vision, and found my mom in her room. I was near hysterics now, trying to find a

way to articulate to her how scared I was of getting older. How, at ten, I felt that death seemed closer than ever. How badly I wanted to stay young and how worried I was that I would no longer be her child. I have blurry memories of my mom gently laughing and comforting me while tears distorted the familiar room around me, telling me how young ten years old actually was. The rest of that day has been lost in my mind.

I'm not sure what series of events shaped me into such a wistful child. What some adults called an "old soul." I look back now and wonder whether it was just "early symptoms of anxiety."

In many ways, I still feel like that ten-year-old. Seventeen years later, I haven't cried on my birthday since, but I still feel that heaviness that comes every year on October 3 and sits inside my chest, both familiar and unwelcome. But with every passing year, that heaviness feels more and more like an old friend. Each year we seem to nest within each other a little more comfortably and I am able to find beauty in aging, in growing, in life and death, and in birthday blues. ᏮᎧ

MOON PIES

My first love
might have been Moon Pies
What's strange is—
Out of all the treats to choose from
I don't even think
that I enjoyed them the most
I think I just loved
Consistency
The idea of a favorite
The concept
of a chocolate offering
from the moon

I should strive to be as kind to myself
As I am to the cracks on the sidewalks
That I still avoid to this day
So as not to break the enchantments they hold,
So as not to break my mother's back.

HAUNTED AND SENSITIVE

've always been a sensitive child in more ways than one. When I was growing up, nothing was more terrifying for me than letting fear run rampant in my own imagination. And my nightmares didn't scare me as much as the chillingly slow, percolating process of my sleepless brain creating new creatures to lurk in the shadows of the hallway that stretched from my room to my parents' like a lightning bolt.

A few times during my childhood, my family rented a cabin in the woods for Christmas or New Year's. Sometimes it was a small place, and sometimes a large one, depending on whether extended family and friends were joining us. These cabins were isolated deep in the woods, or overlooked a large lake, or sat in a row among identical Lincoln Log–stacked brothers and sisters.

I have some beautiful memories from those trips. I remember waking up on the pull-out sofa bed that I was sharing with my two older sisters to the smell of the orange cinnamon rolls my dad baked on Christmas morning. I remember finishing a book about fairies and flying carpets, pulling a loose sheet of cardboard from the packaging of one of those black velvet

coloring pages, and drawing my own intricate rug pattern on it. I dragged it out to the forest floor behind the cabin and sat on it for maybe an hour, willing it to fly away.

I have tender memories of being maybe five or six years old and wandering down a warmly lit, wood-paneled hallway with my new Britney Spears Barbie doll and finding my sisters sitting cross-legged on the floor of the bedroom we were sharing, eating Corn Nuts. I was so excited that they were forced to spend time with me on this vacation and remember them laughing as I tearfully told them I couldn't find the teddy bear I brought with me—he wasn't anywhere I looked. It turns out I was holding it the entire time.

I also have a memory that took place a few years later. Standing on the bottom steps of a wooden staircase in a different cabin, frozen in fear as I listened to my family watch one of those TV shows where people who had experienced hauntings spoke directly into the camera with a sinister vignette cradling their faces. As they shared their brave tales, incredibly beautiful actors reenacted their experiences on a set. There were excessive synths and echoes, screams and bad visual effects. Recently I rewatched the show and was thrilled to find it cheesy and so much less scary than I remembered. But at ten years old, I was petrified on that bottom stair step by just the thought of what I may *accidentally see* on the cabin's TV screen. I was so scared that for maybe two months after that trip I refused to sleep alone.

I can also recall a trip to a bookstore later that year during which, while waiting in the checkout line with my mom, I saw a book cover that depicted a frenzied, wide-eyed, gray-skinned

vampire feasting at the neck of a scantily clad woman. Her hair and bedsheets were tousled, and her eyes were glazed over in a half-asleep confusion as blood trickled down her neck. For the next year I could only sleep if my comforter and several blankets were wrapped tightly around my neck, like a sweaty, down-filled barrier of protection. That comforter and those blankets were working overtime to ensure my safety. Surely any vampire that saw a neck that heavily protected would be too discouraged and heartbroken by their poor luck to try to drink from it.

Another time, I accidentally walked into the room while my sisters were watching the 1990 version of *IT*. The bloody bathtub scene, to be exact. I was petrified of taking a shower for a year after that. I would beg my parents or sisters to stand outside the bathroom door and keep watch while I took maybe a minute-long shower, refusing to close my eyes during the whole duration. Then I would make someone else go into my bedroom first to turn on the lamp for me so that I wouldn't have to walk through ten feet of darkness by myself. My fear and nerves felt like a heavy burden on the rest of my family. An isolating weight on my heart and chest that I had no chance of gaining control over.

I wonder sometimes if I was always an overly sensitive and easily frightened child. I can't think of any one singular experience that shaped me to be that way. It's very possible that's just how my anxiety manifested itself at such a young age, when the greatest worries in my life were the monsters I couldn't see.

Growing paradoxically alongside these fears was a healthy love for Halloween, for magic, mystery, and the macabre.

During the years I was too scared to shower for longer than sixty seconds and sleep with my neck exposed, I was simultaneously trying to get my hands on every single book on violent and malicious fairies and magical creatures I could find. I would spend hours reading about them in "guidebooks" and tracing their beautiful watercolor illustrations. I'm not sure where the line was that separated fascination and fear in my head at the time. For some reason the stories about mermaids with long, skeletal hands and seaweed for hair that lured lost travelers to watery graves or "mischievous and fun" pixies with glowing yellow eyes that were drawn by the scent of blood to ravish any poor injured person they came across in the woods were exciting and mysterious!

Maybe there is some magic in art and the written form that grants us a little more power over the things that scare us the most. I was caught in this push and pull of being both fascinated and terrorized by horror. I think there needs to be a study done on the "kids obsessed with magical creature guidebooks" to "adults obsessed with true crime podcasts" pipeline.

But my personal dance with fear and death really began to shift when I was sixteen. That year, I spent the summer at an art camp in the mountains and made a wonderful friend. The kind of friendship that happens when the spark of weirdness inside of you immediately recognizes itself in another person. We did everything sixteen-year-olds love to do. We rolled down hills between ceramics and painting classes and made a Ouija board out of a large sheet of sketchbook paper with a matching paper planchette. We sat cross-legged next to a large fountain at

sunset and talked to spirits or maybe each other. Something was unleashed within me that summer in those Ouija sessions. We spoke daily through this sheet of sketchbook paper. We solved mysteries and spoke with demons and lost loved ones, the guardian ghosts that watched over us, and the women we had been in past lives. Regardless of whether the spirits we convened with all summer long were real or fake, I came out of that camp fully engrossed in the paranormal.

By the time I was seventeen, the pendulum had fully swung from fear to its extreme opposite for me. I was now hungrily watching those ghost reenactment shows that used to deprive me of sleep. I wanted not only to watch horror shows but to be in them. What was once one of my biggest fears became a scholarly exploration into death and the unknown. I found so much comfort in reading other people's stories and yearned for my own. Maybe it was all a quest to validate the experiences I had with my friend and that paper Ouija board. Maybe I was just trying to make up for lost time, or maybe I was, in some way, trying to comfort and prove to the younger version of myself that I was brave now. I would walk fifteen minutes to the library and read books on hauntings, consuming everything I could. As is often the case for seventeen-year-olds, this newfound fascination quickly became my entire personality, my entire world.

If there is a time to throw yourself into the things that scare you—into death and the paranormal and the unknown—seventeen feels like as good an age as any. When you are seventeen years old, *you* exist in the unknown. You're not yet an adult but no longer a child. You believe that your future relies

heavily on every step you take forward. Every move feels imperative and significant.

It's interesting to contemplate what we carry into adult life from our youth. How many of us embrace the things that scare us and build a life or career around them. The irony is not lost on me that I was once so terrified at the concept of ghosts that it became a burden to my parents and I was unable to spend even a moment alone. Now the word *ghost* itself has become a part of my moniker, my identity. I can't count how many times I've fallen asleep to ghost stories and those cheesy paranormal TV shows. How the memories of intense fear as a child mix with my memories of self-discovery in my teen years, how the memories good and bad bring me comfort now and even lull me to sleep. 𝒢𝒶

How badly I wish

I could travel through time

Pick my younger self up

Dust off his overalls

Let those around me and myself know

He is scared!

We are so scared all the time

Please be gentle with him

Please be patient with me

Please be kind to yourself.

WEST VIRGINIA

Strawberry pie
I'm too tired to run
so I offered my corpse
to the sea and the sun

I fell ill in the attic
with found photographs.
Lost my mind in the forest
blacked out on train tracks

I could blame it all
on unshakable youth.
A cavernous hunger,
sabotaging sweet tooth

How I danced on the edge
Of the hot wildfires
of my wildest years

How I would weep
for those that I love
If the origin of my tears
were spilled from their tongues

How I would thank
the stars that I love
To know they keep writing.
To know they've moved on

GENTLE CHAOS

EAST TOWN STREET

I was full of magic
the first summer
I spent in my apartment
on East Town Street

a calico named Muffins,
a window covered in ivy,
and *Charmed* to fill the silence.

I spent days
speaking to myself
in my pink tiled bathroom.
Letting the sun
kiss my skin
through the shadows
of the oak leaves
that danced for me outside.

I walked through
topiary sculptures
which guarded the library
and checked out CDs
and any book about magic
that I could find

In July
I crafted my own
out of wood
and secondhand art supplies.
Sewed and bound
the pages myself.

I was going to write
in heavy black ink
which I immediately spilled
on my pink bed and carpet.
I was going to fill the pages
with runes, and secrets,
with regrets, and things that I loved.

One Part Grimoire
One Part Diary.

I only ever filled in
the first three pages,
and it wasn't until after
I left East Town Street
two years later

that I realized it was missing.

I am petrified
at the thought
of the next tenant
finding my heart's intentions
tucked away
in the back of a closet.

I am haunted
with the memory
of the boy I was seeing
who texted me once,
out of the blue
"Are you a witch?"

I hope
nobody read it,
nobody stole it,
no other hands ever held it.

I sink deep under icy waves
of panic when I imagine
that somebody sinister
is holding it hostage.

That they are looking
directly at me,
back through time,
to hot afternoons spent
in that apartment
on East Town Street.

That they are the shadows
dancing for me outside
disguised as oak leaves

I hope most of all
that if I offer up
enough secrets
in this new book,
its predecessor
will have ceased
to exist at all.

That some treasures
stay unfound.

That if East Town Street
were to find it now,
they would not look inside.

Please bury my heart for me
among the topiary sculptures.
And lay that hot summer to rest.

AN ODE TO THE DEAD MOTH IN MY APARTMENT

May every creature
Of every size
Of every shape
Take up space

Sometimes a moment of silence
Is simply not enough
of a gesture
To offer up to heaven

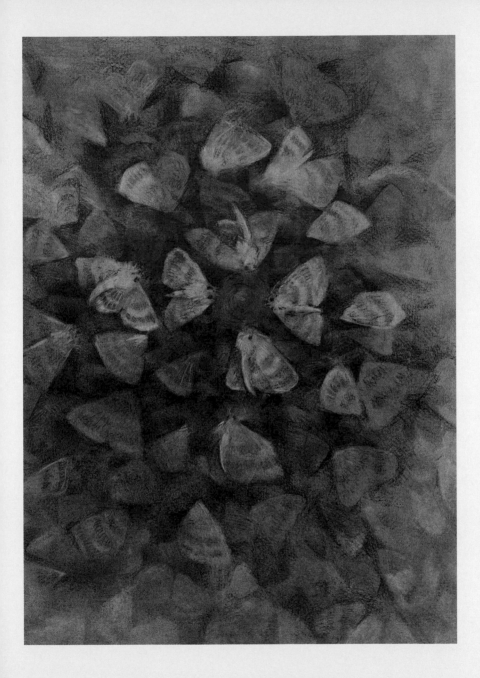

For years I've visited antique malls and spent hours sitting cross-legged on the ground. Rummaging through photos, the precious memories of precious people who have been surrendered to strangers. How intimate it feels to hold a snapshot of someone whose name you don't know. How I panic at the lack of context and the uncertainty of the future, how it terrifies me to think of being forgotten. It seems the least I can do is bring as many of them home with me as I can. Keep them safe in a wooden box under my bed, let their history become intertwined with my own. Honor their photos and the people I've built them up to be in my head, regardless of whether they were good, whether they were forgotten. I hope they've found peace. I hope I will, too.

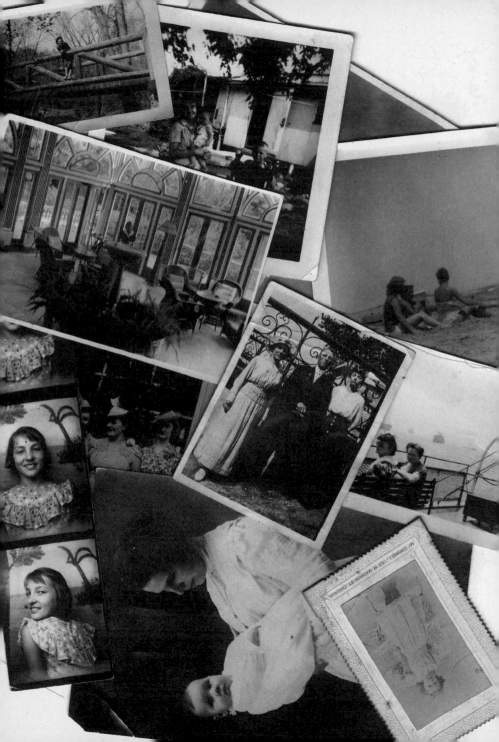

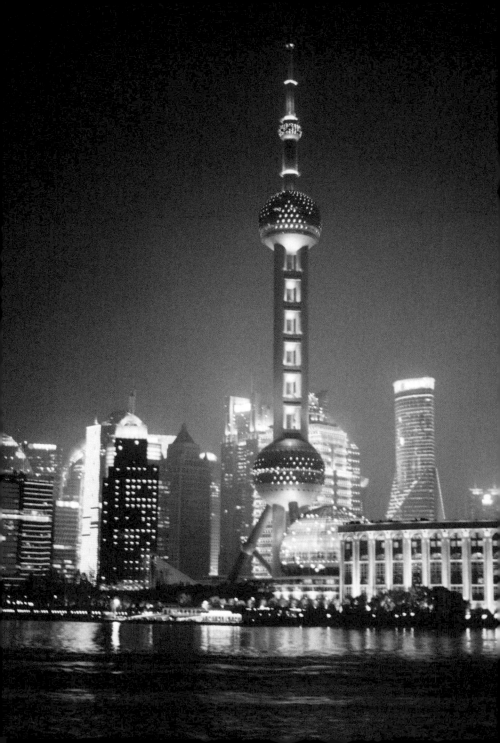

part 3

ON QUEERNESS
AND MAGIC

HONEYSUCKLE

In a past life
I was a garden snake.
That glowed
like a violent beacon
Of neon pink light.

Harmless,
always harmless.
I wove my way through hidden gardens,
hidden thoughts,
and hidden streets.

Igniting the dew
As it rolled over my scales.
Transforming the droplets
in a chemical process
that I never understood
but accepted
Into electricity.
Into candy.

More smoke than solid.
More precious than jewel,
than tissue and sinew.
More tender than
kissed bruises
than loss
of precious teeth
or precious blood

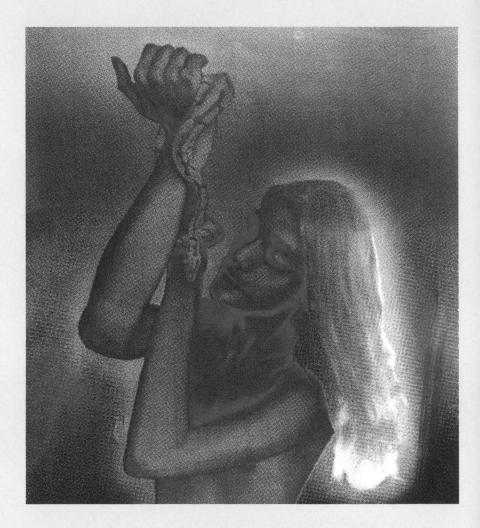

GENTLE CHAOS

VALENTINE

In the Rose over Saturn,
he stirred and awoke
an unnatural occurrence.

He was seen by none,
but nonetheless
glowed pink
with the vapors
of ephemerality
and new life.

Stretched and yawned
against lightning
that illuminated
his face
and his chest

he spoke only
in whispers
and sighs.

For how long
I can't say,
but I watched him

filter down
between the crashing
of cosmic clouds
that formed,
then penetrated,
the cracks
in his skull.

Smiling,
he glided near
above flickering
city lights,
ruby and emerald.

Then sank
through my newly
constructed spine,
traded eyes
for hearts.

Breathed a gentle sigh,
into each of my ribs,
and reverberated
a command
through my being:

be soft, be soft

and I was present.

IN LOVE WITH LOVE

y whole life, I wanted nothing more than to be in love. It was as monumental to me as an odyssey. It was a fantasy that at times rocked me to sleep. It was as colossal and grandiose as the constellations of heroes that battled in the sky. And in moments of longing it kept me up at night and bore heavily down upon me and my pillow. It was a fixation that motivated me and my art even at a young age. It impacted the way I presented myself, and at times it felt like it was driving me mad. Even in that transitional period of my youth before I fully understood my sexuality, the desire to be loved burned so dazzlingly and painfully.

At times, it came to me as a blurry silhouette of a person I couldn't see. An enveloping embrace from an ambiguous figure my mind couldn't quite make out.

The early 2000 rom-coms full of coy smiles, giggling, kisses with swelling violins, twinkling Christmas lights that made the rest of the world melt away—they made me feverish for it. *Love Love Love.* Where was it for me, why not for me, how long would I have to wait, how old would I be?

I knew I desired it, longed for it, but when I saw it up close, I didn't understand. I would stare, confused, at my friends who were dating. I desired so desperately to be wooed, to be swept off my feet, carried away on horseback, to disappear into the person I loved and have them disappear into me. To fall into and lose myself entirely in the ocean of someone else's being. To happily be tossed and lost in the waves. But at the same time, this seemed like pure fantasy, something that couldn't truly happen for me, and I wasn't even sure why. How could I believe in love so deeply but not envision it for myself? It took a very long time for me to realize that maybe it was because, yes, I wanted to be the prince in the fairy tale, but I just as badly wanted to fall for the prince, too.

<center>⚜</center>

I wish it hadn't taken so long for me to understand, to admit it to myself. My queerness isn't something I accepted or understood until my early twenties. Looking back now, it seems obvious that it was always there. Everyone around me seemed to realize before I did. I was fortunate enough to grow up in a loving household with two wonderful parents who always accepted me for who I was, but even still, something kept me from allowing myself to look inward in that way. I have always been a wallflower and analyzer, quietly dissecting and taking in the world. I would keenly observe the actions of those around me, but I would rarely let myself do the same with my own. I didn't dare look too closely. Maybe because I already knew I was different and I wanted to spare myself coming to terms with what that meant.

Maybe it took me so long to understand and accept myself because of outward influences, the state of the world I grew up in, my generation, religious imprints, or even my physical location. Or maybe I am just a timid boy and always have been. What I can say is it's better late than never.

Twenty-seven is still so young, much younger than it seemed to me growing up. It is just as thrilling now as it was ten or fifteen years ago to proclaim that I want to see stars dance in the eyes of my lover when they look at me. I want roses to bloom in slow motion around them as they take my hand in theirs for the first time. I want to be unattainable, to be love itself embodied. Aloof and mysterious. A sad and evasive mystery that breaks hearts and steals time. I want a heart that is yearned for, and badly, so very badly, I want love. I want love, I want love.

GENTLE CHAOS

SAVANNAH

Haze rolling over eyes.
over viridian mountains
and out of lungs.

Tucked between trucks.
Waiting on a boy
outside of gray gas stations.

Drinking sugar and milk and ice.
Pouring sugar in my eyes
to avoid the gaze of mountaineers.

Buzzing hands
steering cars around crashes.
Towards crashing waves
that break my ribs,
braid my hair,
hold me
and carry me.

It is right to give thanks and praise
for the salt water on your skin,
on your teeth
and in your veins.

For shady palms that hide you.
For seashell ruins that hide ghosts.
For floating mosses that hold parasites.
For maple hotcakes that hold pecans.

I could cry
over the waitress's crocheted hair ties.
For sale in the box by the cash register.
I could cry
over my love for the moon

and over the heat
inescapable heat.

I am the heat
crowning my own head
radiating through my bones
and in my feet
as I wander past psychics
Lit up by neon,
moths and hawks,
horses and oaks,
ivy on iron fences.

I could get higher and higher.
Tumble down
drunken cobblestone steps,
dance for the boats that can't see me,
breathe in their twinkling lights
and cry into my sea, my midnight sea.

Crawl back through melting
orangesicle streets,
Sleep three to a bed
on blankets spread over hotel sheets,

savor Polaroids and frozen dinners.
Hidden gardens, hidden hotels.
Roadside peaches,
neon peaches,
peaches inked into my flesh.

I could cry
over the blood that was lost
in my arm, in my shoes.
I could cry
over the saxophone's
reverberations,
putting out the fire
they set to my eyes.

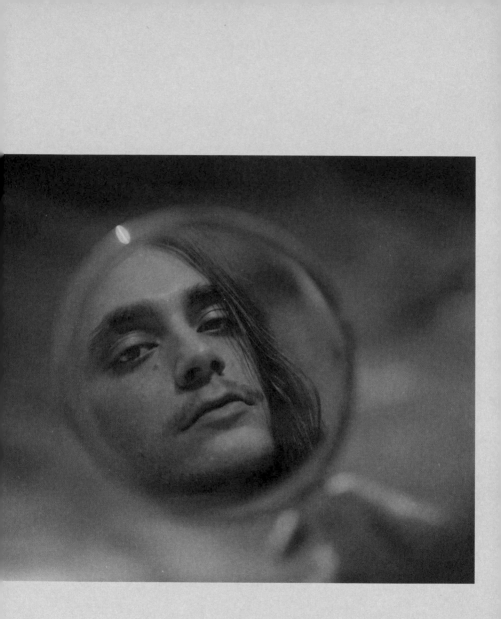

GENTLE CHAOS

One of the first photos my husband ever took of me

What a moment to capture on film

To look back at you through a mirror

Through your lens

We carried that mirror with us for years

Until it shattered on the floor

And even then I was reluctant to part with it

ST. PETE AND STINSON BEACH

To be lost
and hypnotized
without a name.

To have cried
in a heavy
sea-spray-lit daze
on the side of the highway,
over two beaches
that have never met.

To find your voice
hot with sea salt.
To have wandered so far
for a home.
To know only
getting lost on the way.

Say goodnight
to the cicadas,
whose ceremonies

create an electric cacophony
late in the mist of the night.

Goodnight to thick air.

Goodnight
to amber streetlights,
amber waves,
and sinister shadows.

Say goodbye
to love known and lost
in a Floridian haze.

To lives lived.
In states forgotten,
States overgrown and green,
to Hollywood fame

How sweet to cut my hair
and make a ghost of your name.

shells. I can't remember where they're from. Malibu? St. Petersburg?

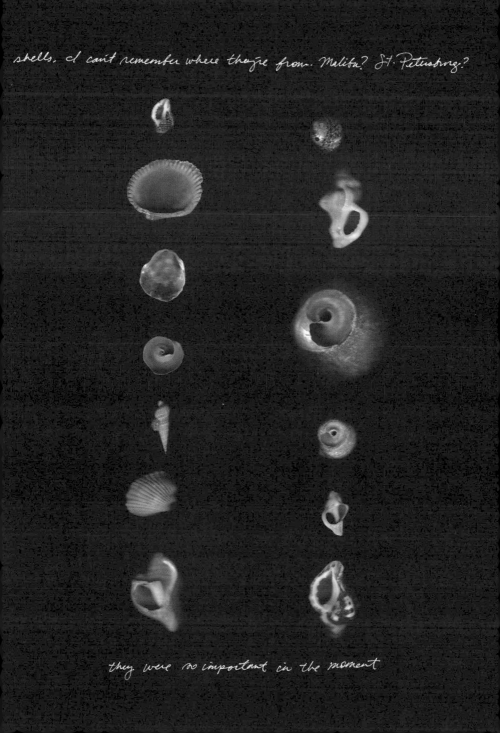

they were so important in the moment

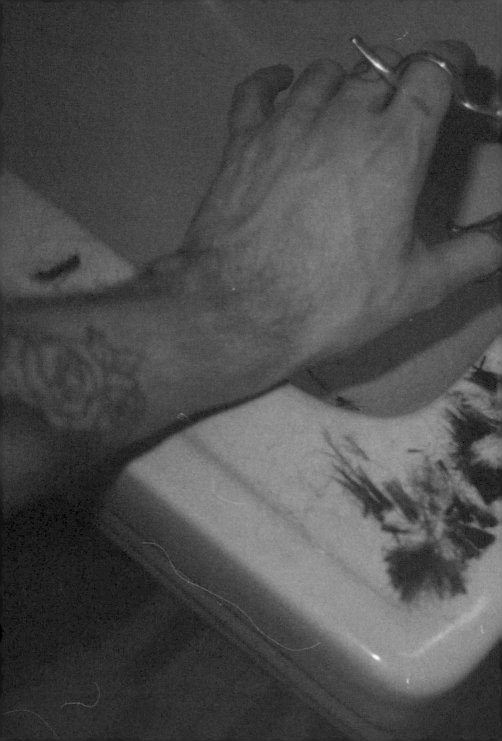

it is hard to explain
but I love nothing more

than subverting
the expectations
of others

As a child
even temporary tattoos
made me cry

so I decided
to cover

my body in them

GENTLE CHAOS

as soon as I
became known

as the boy with long hair

I wanted nothing more

than to shave it all off

HAVE GHOSTS
SEEN ME NAKED?

I don't know what it's like to become a ghost, but I imagine it's similar to opening a can of soda, your soul being the carbonation. Bubbling out of your body with this resplendent, effervescent energy. Slowly dissipating into the air around you, your energy deliciously fusing with the fabric of the universe particle by particle.

With that being said, I don't think ghosts are necessarily peeping on us while we're in our most vulnerable state. Or, at least, I don't think *most* ghosts are. Why would any ghost take a respite from exploring the boundaries of time and space to check out your ass? You know? I mean, maybe a couple of ghosts would. I can't speak for them all.

I am going to firmly believe in my own theory because one time a medium asked me whether I was aware that there was a strong female ghost watching over me. I thought to myself, *I knew it*. All my life I have been waiting for external validation from a paranormal professional that I was being haunted. That there was some strange ancient entity tethered to my soul, that some awestruck medieval knight who was bored of the afterlife

found me charming and followed me day after day, watching over me in my sleep. He said she was related to me, an aunt-type figure with dark hair and sharp features, very glamorous. Covered in jeweled rings and big bauble necklaces. He said that in her time, she may not have really understood me, but she was ecstatically cheering me on and watching over me now.

I've dug through family albums with my mom and looked for faces that jumped out to me. Looking for her. It could be my great-grandma Virginia, whose face is blurry in my mind but whose soft, gentle hands I can still feel. Or my wild great-great-aunt Nellie, who let her hair grow past her waist and rode horses bareback. After a while I decided that it didn't really matter who it was. How comforting to think that someone who may not even have known me in this life is rooting for me and cheering me on in the next. A ghostly cheerleader. I like to think we all have at least one. That they are a guiding presence in our lives, radiating support and love that we may not be able to hear but can sometimes feel echoing deep under our skin. Maybe they are gently guiding us away from danger and shielding us with their love, and hopefully they turn around and close their eyes, should they still have any, every time we disrobe to get in the shower. ᏏᎾ

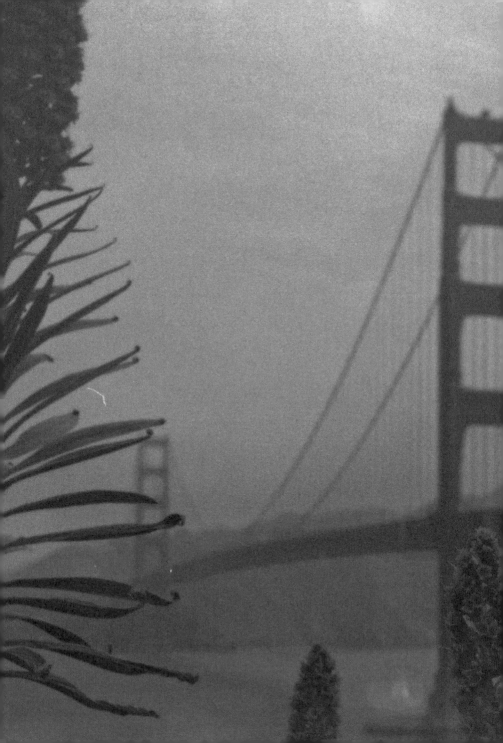

FOR SAN FRANCISCO
AND FOR THE
WOMEN WHO FEED
WILD ANIMALS

hen I was young, I read books about a child detective who lived in San Francisco. I can't remember what the series was called, but there were beautiful, moody illustrations that showed a herringbone-clad investigator bracing against strong winds, and every adventure ended in pancakes.

I remember telling JiaHao, my now-husband but boyfriend at the time, about those books as we landed on our first trip together to San Francisco in the summer of 2018. Our plane arrived late at night, and as we were getting up out of our seats to leave, the woman next to us said, "I hope you both have a good trip." How sweet, I thought, for this woman to sit next to these two boys in silence for four hours, and then to wish them the best at the last moment. To be outside of the conversation but present for it all. I love listening to conversations that can't help but be overheard, and to contribute my small piece as well. In restaurants that are too closely packed, in airplanes, in elevators. My father is an expert at this.

We rode to our first Airbnb in the dark, and I remember staring in reverence at the twinkling lights of crooked houses embedded on the hillside. The next morning, as we rode the BART to a friend's graduation ceremony, I heard actual music in my head. A melody that came out of nowhere. A voice and symphony, rising slowly and cinematically intoning, *San Francisco, San Francisco*. I was here, and there was magic. There were days when I partook in every conversation but still felt alone in the crowd. There were days I looked out at the Pacific and felt ecstasy and melancholy battling each other for supremacy.

We returned a year later in the summer. JiaHao applied for a job as a photographer for the San Francisco water and power company, had made it through the first round of screenings, and was given a time and date to arrive at the City and County of San Francisco Testing Center to take a photography test. I used some of my vacation days to join him.

I was desperate to feel that sense of magic and awe again. Ohio, which we called home at the time, is magical too in a way that is quiet, green, and both large and small. But I was exhausted and run down. I felt ancient at twenty-four. My body constantly hummed with a static electricity that lifted the hairs off my arms and dulled all my senses. I needed San Francisco to make me feel different.

When we arrived the second time, we dropped our bags off at an Airbnb that we were sharing with several strangers and walked down to a bakery at the end of the street. I had been in a bad mood all day because I woke up twenty minutes after I'd meant to, and although we made it to our flight and arrived at our

destination just fine, I couldn't shake the feeling that I was going to be late. As we were eating, a girl came up to me, her boyfriend standing a little behind her, and said, "I just wanted to say I love your videos." JiaHao stared at me with his mouth open as my face turned bright red. It was the first time I had ever been recognized, and it was bizarre and exhilarating. I was still working my day job and teaching drawing to adults in the evenings, and I felt tiny and invisible. I hadn't even really told friends or family that I was trying to carve out a niche on the internet that was my own.

At the time, it was a small secret that I shared with few. I called it Ghosthoney, and it wasn't an alter ego or a personality I had crafted; it was just a way to retreat from my daily work. It was and is created in tandem with strangers on the internet. I wish I could take credit for it, and maybe I can for what it's turned into—for how *I've* become Ghosthoney—but its world has only ever felt partly mine.

While JiaHao took his test, I rode the BART to the Mission Dolores Park, sat at a picnic table by myself, read a book, and burned the back of my neck. Most of that trip is a blur. JiaHao humored me as I frantically retraced our steps from the year before, trying to recreate what I'd felt then. How strange it is when our bodies begin to fear and forget how to relax.

We shared the last Airbnb of the trip with a household in the Outer Sunset. Our room was white and decorated with fake flowers. Every night we heard shuffling outside our window and watched as the matron of the house stood in her garden under the moonlight and called for the local raccoons.

They crawled from under rosebushes and trash cans and sat for her, waiting while she tossed them broken tea biscuits. She noticed us in the window and was eager to tell JiaHao her entire history: the hardships, the son she raised and gardens she's tended, the things she nurtured, and the things she sacrificed. I retreated to the bed and listened to them converse in Mandarin. JiaHao leaned out of the second-floor window while she looked up from her spot in the garden, straining her neck. He offered only the occasional "ah…" or sympathetic "oh…" while the nursery of raccoons grabbed with tiny hands around her feet for the crumbs of dropped biscuits.

<center>∽✦❀✦∽</center>

One year in the future, now living in California, we encountered another woman who loved wildlife in this way. Every night we heard the woman whose backyard met ours ring a bell to summon the cats she cared for. In her generosity, she was unaware of the opossums that she had trained as well. Under one lone palm and a blazing neon cross, she would ring her bell, call out to the night, and go back inside. I would watch from my bed as opossums waddled from the alleyways to eat the cat food she had left behind.

These women were a comfort to me. When I was a child, my mother volunteered at a wild animal rehabilitation center. Our house was full of cats, dogs, rabbits, and finches. I grew up in awe of the deer and the foxes. It was not unusual to dissect owl pellets for fun. She told me once of an Oklahoma night full of thunder and rain when she went in to the center to check on the

animals and found a small duck soaked and shaking in the cold. She picked it up and held it tight under her shirt to keep it warm. That memory feels like it's just as much mine as hers somehow.

I think so often, too, of Ms. Yu, the retired librarian from the art school where JiaHao and I met, who filled a campus with books and with gardens. Who worked for forty-six years and retired and has still shown up there every day since because someone needs to feed the birds and tend to the gardens. How she agreed to come to dinner with us on our wedding night. How she sat by JiaHao, and I sat by my parents, and we all looked like a family.

I dwell on the moments when I felt electric in good ways and bad. On the defining locations in my narrative, the environments that built me and buried me. On the women who have impacted my life. Those who give, sometimes getting little in return, and the magic that they hold. I think of the women who feed wild animals, of mothers, of San Francisco and her sweet, cold winds and steep hills, of twinkling lights and the music that she radiates for those who call her home, even just for a day or two. I think of raccoons and opossums, of airplanes and pancakes, of the sweet kindness of strangers. I feel grateful for them all, and I hope, in the moments when I am frozen in fear, that I am able to emulate for others, even long after I am gone, how they all made me feel. ᡣ�

SUMMER RAIN

You are needed, mourning dove

In all the turbulence
And inner turmoil
That can be hard to shake off
That falls heavy on your heart
like summer rain
on linen sheets

It feels burdensome to admit
That tall grass
can be cleared
No matter how long
it was left
to grow unattended

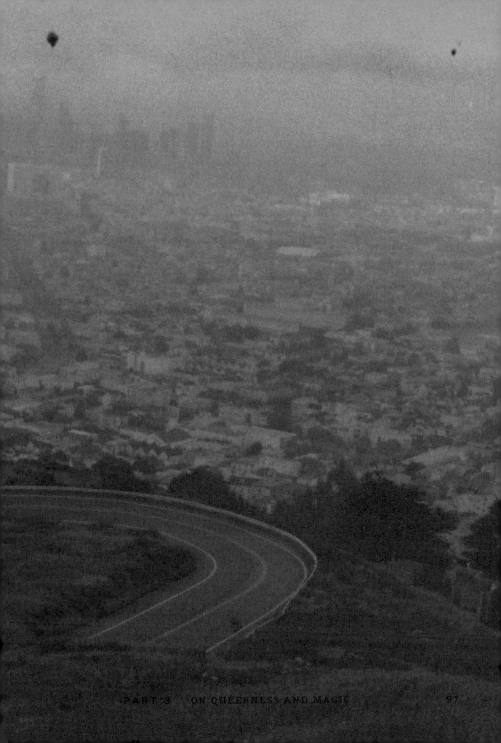

collected off the number one highway 2018

sunprint July 9th 2021

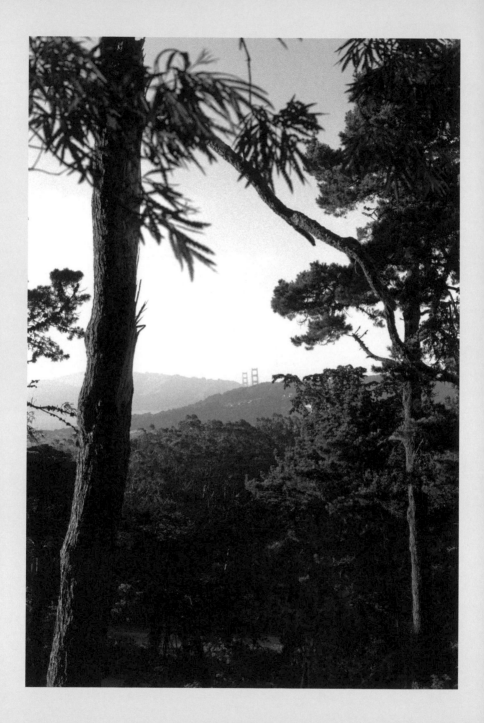

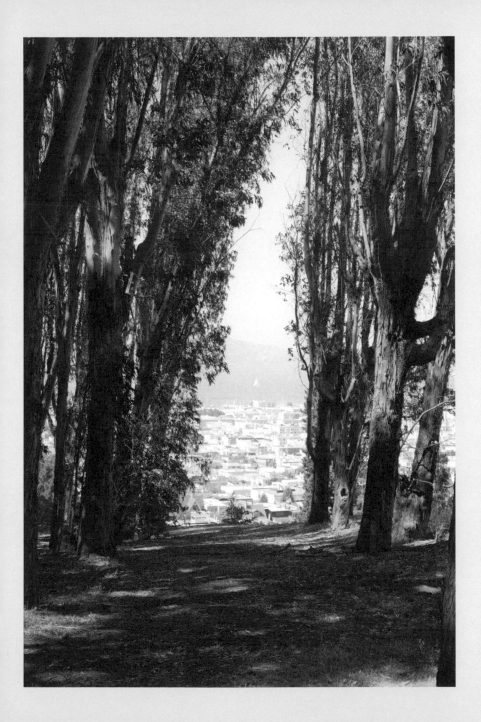

GIVE MY SOUL
TO THE BIRDS

Every time I run my fingers

Through my hair and pull loose threads

I let them fly off in the wind

So birds may take them for their nest

And weave my soul into their home

Sing for their young

Sweet chickadees

Sing for hydrangeas

In the sun,

the rain

Weave my soul into your home

Little bird

And when you're grown

Your nest forgotten

Two years from now

Know this—

I'm in the soil

and in the wind

I'm in the mountains

practicing death

and worshiping life

Every time that I let my hair fly

he made me a ring
he made me a ring
he made me a ring

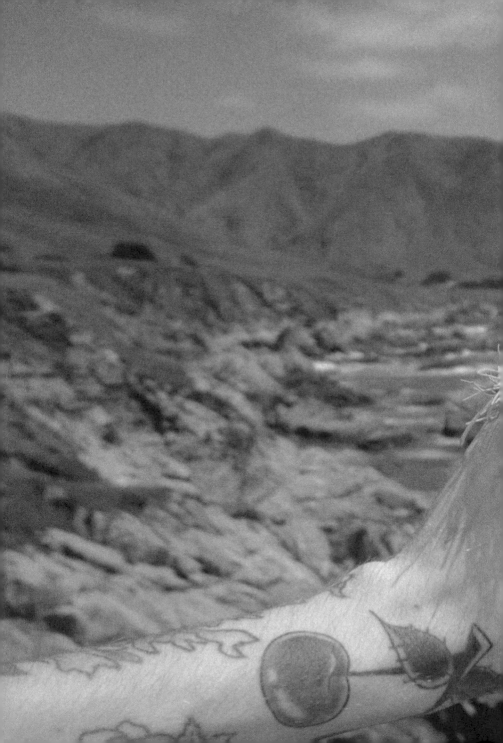

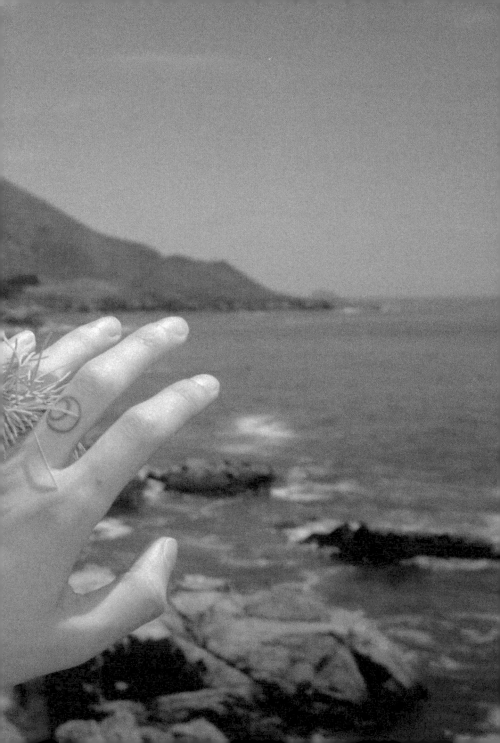

THE BONES OF
THE HOUSE

After two weeks

of seeing each other,

he gave me a ring made of sharp scrap
wire twisted with pliers. It ripped my
T-shirts, and scratched my face, and
pulled threads from my sweaters.

I invited him in to collect bugs from my
apartment for a carnivorous pitcher
plant named Virginia bought on our first
date. We talked for eight hours straight.

He came over to my small studio
apartment where we shared its pink
tiled bathroom, and he never left.

On the third or fourth night we watched
an incredibly bloody movie about
expensive fish and I thought, we could
do this forever.

After four months we moved into a tiny
house far away from everyone else.
There was a large backyard with tall
grass. It was hot and we fought a lot.

I took him to Florida, a state that makes
me feel like I'm being watched

from behind the palm trees

and from between the blinds

of old pink and yellow apartments.

I shaved my head and we traveled to San Francisco, a city that I felt, growing up, was maybe only a dream.

We met old friends, we drove down Highway 1, I found that you can't outrun depression.

I found that I was never happier than when I was in Monterey and that I was never sadder than when I couldn't find joy in Carmel-by-the-Sea.

We returned to our tiny white home in Ohio and lasted there eight months. Wild fights over hypotheticals and things we can't remember now. We sowed wildflowers in the back garden and called the home cursed.

He left for China for one month and I sat in the backyard with a new dog, far away myself. The day he came back he proposed. That fall we moved into a smaller apartment in German Village in Columbus.

Brick streets, covered in moss, and pink petals in the spring, yellow leaves in the fall. Old homes that smelled like dust with deep basements hundreds of years old.

Pumpkins, gas lanterns, hidden gardens, iron fencing, and statue-filled parks. The day we got the keys, one of the four engagement rings I'd gotten him was waiting in the mailbox, and I proposed too.

Our tiny room in the attic was too hot in the summer, too cold in the winter. My head was kissed by the ceiling every day.

January we got married in front of my parents and a judge and walked through piles of snow to eat breakfast.

In September with family close and extended we celebrated in the haunted house next door to the apartment with the pink bathroom tiles where he first came over to collect bugs.

You took me back with you to China.

Introduced me to your parents, their parents, aunts, uncles, their convenience store, cousins and their bakery as your friend from overseas.

You showed me your elementary school, the graves of distant relatives, the homes you were sent to as a child, and the gardens you stole from.

I took pictures of every street and walked arm in arm with your grandma through tiny markets where she bought me vegetables, candy, and nuts.

We sat around in a circle in the stone house your grandparents built and died in. Holding bowls of hot water in our hands, wearing our winter coats, my pockets weighed down with small oranges.

The only pair of white shoes I brought with me got soaked in the rain, and as your aunt was blow-drying them for me under an image of Jesus I wondered how close I could get to a family that doesn't speak my tongue or know that we're married.

We got sick, we got better, we saw fake memorials and brightly colored fake trees in Hengdian, walked through Shanghai, Wenling, and Hangzhou, and in every temple along the way I prayed for health and safety for us and that I could share my thoughts with the world and that there would be people eager to hear what I have to say. And everything was beautiful, and new, and I was so hungry.

We flew home and the world shut down. We wandered through brick streets day and night, exploring every alley and panicking about a future that was too blurry to see. We lost our jobs on the same day, our security, and even though we were glad to be free, you had to comfort me while I cried.

We said goodbye to very few and we
drove for five days. Leaving a place
where I wasn't born, where I wasn't
raised, a place where I lived my messiest
directionless years.

I was confused about how I even came
to be there. How did I get stuck in that
place? How did you choose to go there
from overseas?

We stopped in Oklahoma near the city
where I was born. I could have shown
you my childhood home, the resting
place of my great-grandparents, but I
just wanted a new home. Three years
and four apartments later, we made it
back to California.

Now we sleep between mountains

and under the light of a neon cross.
When we drove into LA, we cried at the
trash on the streets and how tall the
palm trees were.

Everything was beautiful

and large and terrifying.

I've gone to every cemetery needing proof
that people have lived here, and loved
here, and died here.

If we ever flee Los Angeles, where will
we go? I crave land under my feet.
A place and streets to know intimately.

I am happy to be small here and to be
seen here, but I don't feel worthy

to love and to sleep here. I feel like
we're older than we are, that we've aged
rapidly together.

———

Will we raise children or gardens? I don't
need fame or even community.

I thrive in isolation, and I am scheming
that one day I will disappear from the
persona and life I have created.

———

What if as we grow older we no longer
grow together but apart? And what will
happen to me when you are gone? Or to
you when I am gone? It only seems fitting
in your absence to retreat to a tiny home
by the sea, see no one and never speak
again. All I can ask for is for my love to
flourish in the silence, to grow old, and
die. Be buried under a tree

where artists and quiet children will
come to pray and be.

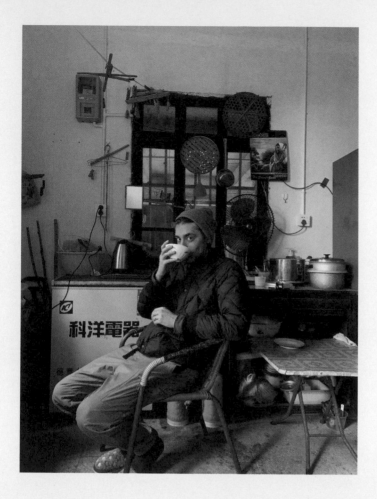

GENTLE CHAOS

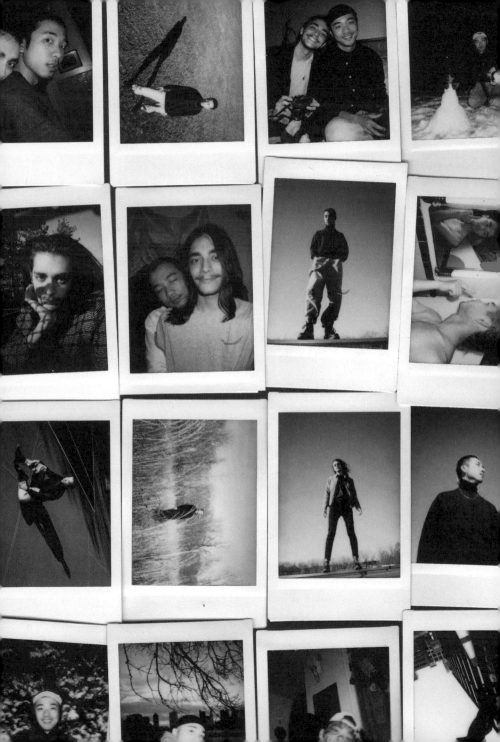

Remnants from ceremony past
Captured on my first roll of 35mm film
On the first camera I ever received,
Next door to the apartment I spent long
 summer days in.

Years later I would walk through this garden
 by myself
Taking a quiet moment away from our friends
 and family inside
To admire the beauty of the greenery
The dark, billowing storm clouds
and my new shoes on stepping stones
That I had walked so many times before

the garden next door
 that I wandered through
 for years and years

I hope that if I ever die
my soul can walk this path
like it did on our wedding day
a little drunk,
 with heavy rain drops

 kissing my head

wedding day roses

our teeth

PRAY SELFISHLY

I sent up a digital prayer in Shanghai.
Broadcast on the temple's
LED screens
for all to see.

I wished for a long,
happy,
healthy life.

You encouraged me
to indulge in my greed.
To ask, since we are here,
for a small sprinkling of fame.

There is nothing
more gorgeous,
more precious to me,
Than to bear witness
to those living in the vertical.

In buildings so tall,
that I found only disappointment
two months later
In Times Square,
whose buildings and height
Seemed to pale in comparison.

How privileged I felt
to pray selfishly.
To see fleeting glimpses
of microcosms
in the smallest of alleys,
in the hand warmers
of every parked bicycle and motorcycle

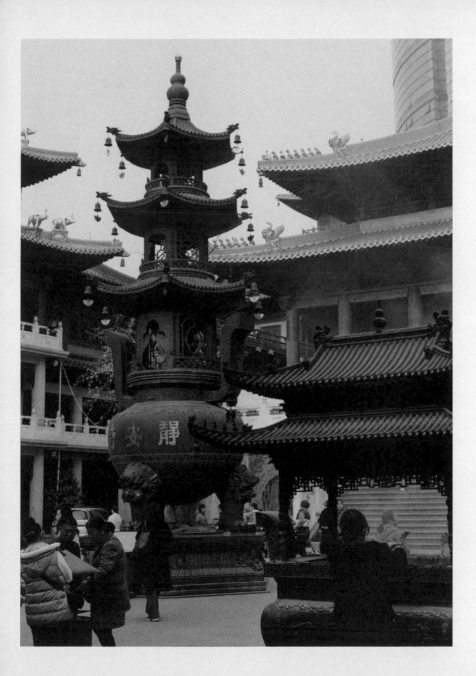

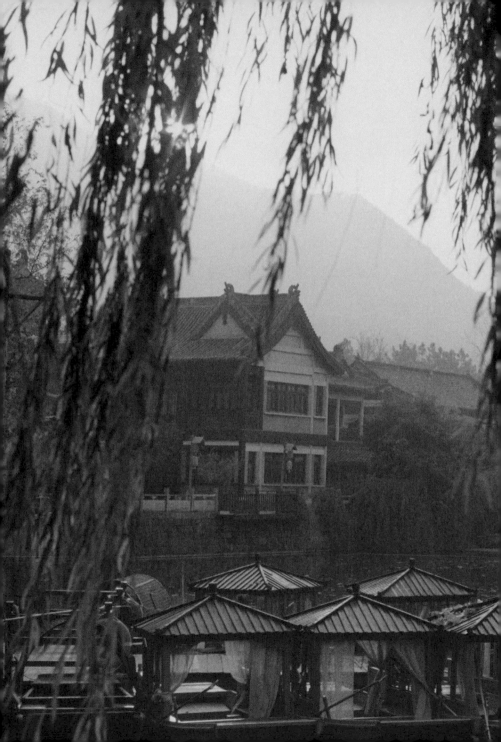

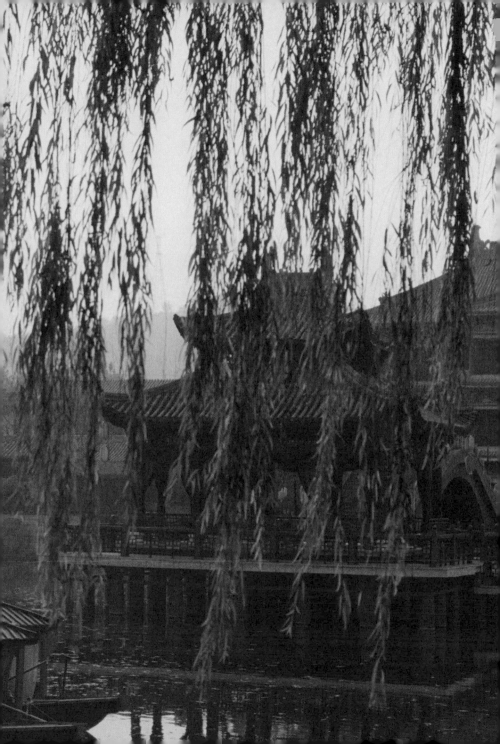

GENTLE CHAOS

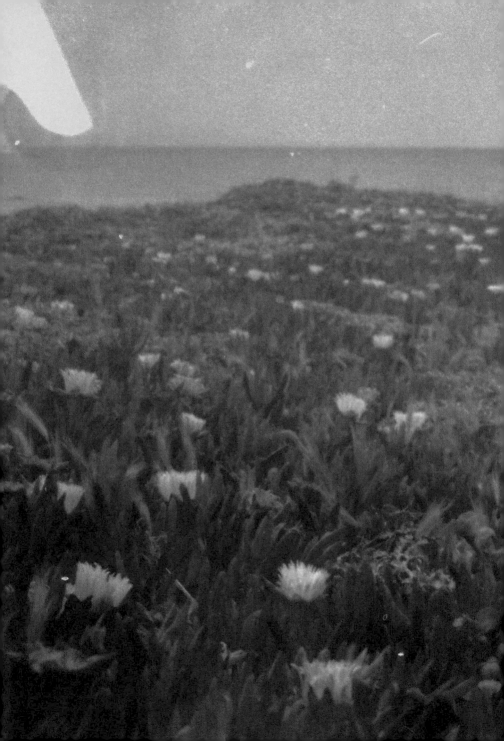

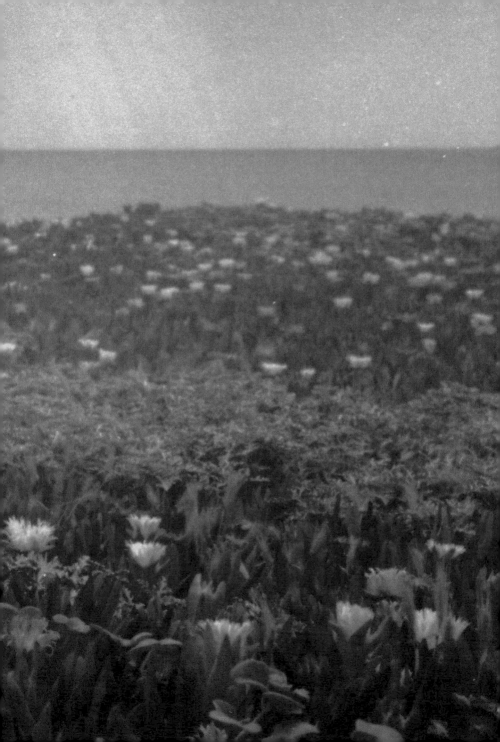

35MM

n our first trip to California, I brought my new Minolta XD700 camera and was thrilled to take film photos of houses, landscapes, and landmarks. I still needed help loading and unloading the film, but I was excited and proud to carry it around with me. After working full time at my first job for a few years and losing all desire to create—to express myself through drawing or painting—35mm film felt liberating. Like I was dipping my toes back in the water. It was also exciting and new—I loved scanning in the film and experiencing the surprise of how the images turned out. I loved how tangible it made my memories feel, how special. Even if they were blurry or distorted, they were now art to me.

As we parked our car somewhere along Highway Number 1, looking out at the ocean, the rocks, the seagulls and seals in the distance, I tried to wind my finished roll of film by myself and place a new roll in. Somehow I rolled too far and heard the film rip inside and break off in the camera. My heart sank and I instantly panicked and handed my camera to JiaHao, my photo teacher. He immediately threw a jacket over his hands and my camera to create a makeshift dark room. Without being able

to see what he was doing, he opened the camera and manually rolled the film back inside its canister. He saved the images, but the jacket had still let in a little bit of light, burning the film in the process. These darker, burned photos became some of my favorite images of all time. The colors are deepened, the quality less than great, but I love what they've come to represent. How they illustrate my eagerness and naivety and his ability to repair.

Sometimes I am asked for relationship or marriage advice, something I feel very underqualified to give. Even now, writing this at twenty-seven, I still feel too young to have any substantial knowledge. Sometimes I can't believe how young we were when we got married. But I do think that if you can find someone who is calm in the face of your panic and mistakes and who is able to help you fix it, it doesn't matter how young you are. That is an incredible quality to find in a partner.

When going in for our green card interview, we were understandably nervous. Even though our relationship and marriage were legitimate, having to prove it in separate interrogations was unnerving and disquieting, no matter how long we'd practiced each other's mothers' maiden names or the prefectures and cities we grew up in. As we sat in our suits being questioned individually, the interviewer asked us each one thing at the end that we had not anticipated: "What is your favorite quality about your partner? And what do you think his favorite quality of yours is?"

I remember being silent for a few seconds as I let the question sink in. "He's kind," I said rather quietly, and I immediately felt like that was a weak answer. But it was true. He would

go above and beyond for any stranger that he met. "He's one of the kindest people I've ever met."

"And what quality of yours do you think is his favorite?"

"He says I'm very patient." That one was a little easier to answer. He had always praised my patience no matter what we were doing. I'm proud of it, too. Whether I'm hungry or tired, angry or upset, I'm good at tucking those feelings away and dealing with whatever task is at hand. The interviewer told us we would hear our results in a few weeks but that he didn't think we had anything to worry about.

We walked outside after our meeting together and immediately started talking about how the last question caught us off guard. I asked him what his answers were.

"I told him you were very patient," JiaHao said. "And I said you probably like how kind I am."

My heart swelled. Everything about our relationship felt reaffirmed in that moment. "Wow, we're really good!" I exclaimed, and we drove home.

There are moments when things aren't easy for us, and it's wild to think how much has changed and how much *we* have both changed since we first met and got married. I sometimes feel like as I get older, I'm somehow becoming less patient than I used to be. But at the same time, that memory is something I hold onto so tightly. Whatever the future brings, however we both change, if we can just remember to be kind, to be patient, there's not much else we need to do. ༄

Where will my love go?

What will happen to my wedding photos?
How does such precious history get lost to time?
I've been given the chance to immortalize words
 on paper.
So I am combing through my memories
Shining light into every corner of my head.
What do you say?
What do you leave behind?
Above all else I ask

Please do not forget my love.

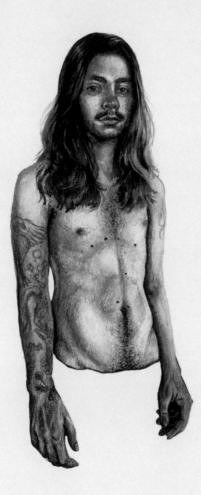

GENTLE CHAOS

part 4

GHOSTS AND HONEY

what is ghost honey?
honey made from
ghost bees?
a sweet name for
 a loved one thats
 gone too soon?
equal parts spooky.
and sweet
cryptic and alluring
just a name and
nothing more?
~~sweet~~ something
to hide and create
behind. a gimmick
~~a wish to be re-inve~~
a wish to be someth
bigger than myself
a chance to make
something new
just a name.
its just a name.

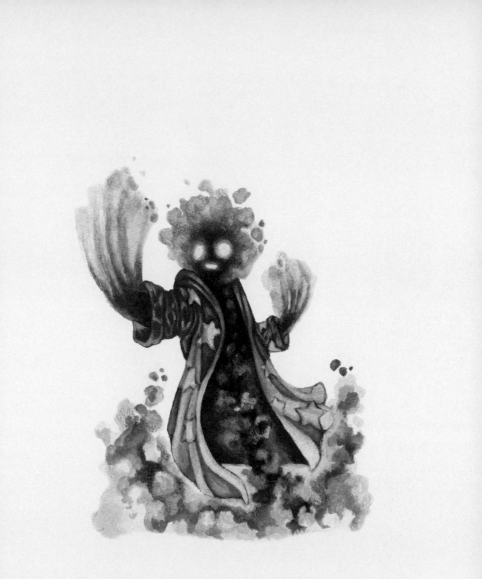

THE GOBLIN OF ALL LOST THINGS & STUFF

 shadowy and misty enigma. Their true form is noncorporeal. They are transient and love dark and warm spaces: the inside of a closet or under the bed. Easily mistaken for a ghost or shadow person. They are the reason for the majority of "misplaced" items, whether socks, hair ties, or jewelry. They swipe these items when no one is looking, and through an ancient process, deconstruct their matter and absorb it into their being. The more of their mother-host's items that they absorb, the more they begin to resemble their mother-host. This usually isn't a problem as they are restless and do not stay in one place for very long. If they are presented with and fed a diet of items they are allowed to call their own, they slowly shed their previous hosts' characteristics and are able to live freely as themselves.

Their personality can be described as chaotic neutral. They are typically harmless; their bark is much worse than their bite.

I'm not quite sure where I got the idea for the Goblin of All Lost Things & Stuff. My original video that featured this character came out at a time when I was churning out original fever-dream-like content seven times a week, hoping some of it

would stick and capture people's interest. I think it all originates from the question, Where do our lost possessions (hair ties, socks, etc.) go? As with most of my work, I just let my imagination run rampant from there.

What if those things are stolen by goblins that live under your bed? What if the goblin feeds off of these stolen objects little by little until they morph into the person they're stealing from? I have no memory whatsoever of where the transatlantic accent I gave this character came from. That was a creative choice in the heat of the moment. But two years later, after revisiting the character and trying to expand on them and flesh them out, they became a lonely, sentient vortex of shadow and mist. Some strange combination of a boggart and a hobgoblin. They existed by slowly siphoning personality characteristics from other people. I thought about how lonely that must be.

Later, in my fantasy fiction narrative podcast *Ghosthoney's Dream Machine*, Ghosthoney accidentally gave The Goblin of All Lost Things & Stuff a name: Rose. This was the first time the goblin had been given an aspect of individualism, something they could use to shape their own identity. That and a small offering of "fresh and unused" socks helped Rose find themselves.

I really love writing for Rose and exploring their past. I love the idea that they were enamored with old Hollywood and proud to have leeched off some of the biggest stars at the time. Something about a shapeless void of shadow and mist that eats socks and likes to indulge in a glass of bourbon makes this probably my favorite thing that I've ever created. ᕭ

GENTLE CHAOS

BARTER FAIRIES

idiculously mischievous, almost *too* mischievous, barter fairies are incredibly persuasive and skilled at hypnotism.

There are good and bad barter fairies.

The good barter fairies devote their lives to helping those in need. They seek out people in desperate situations and make reasonable trades. Should a farmer be desperate for rain, a good barter fairy may appear and trade rain for a loaf of bread. They feed off the gratitude provided in the exchange. They sometimes can be overly generous. In their eagerness to assist humans, they may overdo it, provide too much rain, and cause a flood.

The bad barter fairies live off the memories and sentimental magic that radiates from deeply loved possessions. They sniff out these objects and trick the owner into making a trade using their hypnotic and persuasive powers. They feed by polishing their traded items and sniffing the memories and sentimental energy out of them. The more deeply an item is loved, the longer they can feed off it. Once they have sucked an item dry, they trick someone new into trading *their* beloved item for it. And the cycle continues indefinitely.

The original barter fairy concept began as a dream one of my followers had and tweeted at me. Something along the lines of "I had a dream ghosthoney drove an ice cream truck around my neighborhood but was selling sunglasses, only HE picked the sunglasses for you." I made it into a slightly more ominous video, and I think to this day it's my most-viewed comedic sketch.

It's definitely one of my favorites, but for a long time, even I had a hard time understanding the appeal of it. I think because it's slightly off-putting and sinister—and offers more questions than it answers. For a long time, I considered creating a sequel, but I'm glad that I didn't until now.

In *Dream Machine*, I've recreated this concept but made the Iced Creams Man even more sinister. He morphed from a semi-vacant and smiling ice cream man to a magpie-like greed-driven fairy who feeds off stolen sentimental memories and energy, and eventually he gained a name: Maurice. I am particularly fond of characters who start out as antagonists and slowly morph into beloved side characters. I think Rose the Goblin of All Lost Things & Stuff and Maurice the barter fairy are both examples of that. ᘜᕈ

THE HOUSE IS ALIVE

hroughout my childhood, my mom would often take me on tours of historic homes. It was always so overwhelming to me to enter a house that had been preserved to reflect how people lived in it hundreds of years ago. To see firsthand what it means to honor and hold space in a specific physical place. It's hard not to walk out of buildings like that and see every home around you differently. If only walls could talk.

I joked once in a video (although my sentiment was serious) that I wish I could experience omniscience only when it comes to houses. Like some sort of cinematic camera shot, I would soar over a community, sweep through every apartment and house and instantly know its history. Like driving through a city at night and seeing all of the lights flicker from the different apartments, or traveling down a street in winter and seeing a house proudly display a Christmas tree in the window, there is something comforting about just witnessing life exist. Experiencing a space that is lived in as someone else's home. I really do believe that we imprint our energy on physical spaces.

I wanted to create a world that revolved around a house where anything was possible. The result is this decrepit,

pink-and-purple, narrow Victorian home that I built in my imagination (and later on paper and in sculpture), where goblins live under the bed, the staircase comes alive at night, and the rooms switch places occasionally, almost as if they're playing a practical joke on you. The mysteries continue to unfold organically the more time I spend thinking about this house. I hope they continue to do so, and I hope the mysteries never end.

GHOSTHONEY'S GUIDE TO DRESSING LIKE A LOVE-STRICKEN VICTORIAN DANDY

1 Shirts must be silky and flow like the tears of a red-faced newborn. (Bows around the neck will emphasize your delicate disposition.)

2 Pantaloons: keep them high waisted. (This lengthens the leg and highlights your most delicate assets.)

3 Only show ankles as a last resort.

4 Only wear the fur of an animal you'd be willing to strike down with your bare hands, and practice subtly flaunting the gifts of suitors past in the mirror. (Jealousy is your best friend and man's true weakness.)

5 Give off the aura of a forlorn ghost wandering the moors. (Do NOT be afraid to gaze out of a window longingly.)

6 If you are not getting the attention you desire, consider holding a candle close to your face under the moonlight. (If they mistake you for an other-worldly apparition, so be it.)

7 Shroud yourself in honeysuckle, roses, and lavender. They should still be able to smell you long after you're gone, and whenever they step into a garden they will think of you. Use that association to your benefit.

8 How many suitors is too many suitors? Trick question; numbers are for scholars. Have any and all suitors duel for your love and attention.

9 It's good to build your own enterprise. Bury gold under loose floorboards or sew spending money into the back of your favorite armchair. If you need to make a quick escape and start a new life, it is good to be prepared.

Good luck on your quest! Go seek your fortune.

THE TOWER

I feel myself
both crumbling and green
Succumbing to the lore
I've built up around me.

In the coldest of stone
I am falling asleep
My head held aloft
By a sea of ivy

I can be whatever
they want me to be
In a way
it is what
I searched for in my dreams

But the burden is heavy
And worse than I feared
even heavier now
than the nest of my hair

So I've taken to seizing
my own silken thoughts

Pulling and guiding them
Hand over hand
Knitting with my long fingers
These thick woven webs

To cast over the windows
For those who pass by
For strangers
For neighbors
For the whole world to see

Here lives a wild man
who must be so free

TREES I AM
GRATEFUL FOR

✳ The fig tree in our Virginia backyard. It was sprawling and
wide. I spent so many afternoons by myself sitting in its branches
waiting for magic. In the summer the tree produced more figs
than we could manage, and they would gather and rot along
the roots, providing a feast for the swarming flies.

✳ The magnolia tree in our neighbors' yard. Its sweet and
somehow cooling aroma, its vibrant red, waxy seeds that I
would crush between my fingers.

✳ The giants in Muir Woods. I feel a little selfish and embarrassed
to say I thought they would be taller. How greedy a man am I?

✳ The Wisdom Tree in Los Angeles. Who was the first person to
pour out their heart into a composition notebook at its base?
How many journals have been filled there since? How much
energy can be spoken into a space until you have to call it sacred?

✳ Golden dewdrops. Hauntingly beautiful and toxic. The first
time I met one, I fell in love with the whimsy of their design,
became terribly enamored with their exquisite blue flowers.

Unaware that the delicate golden berries that beaded their branches were heavy with poison. A tree has never looked more inviting or like it has purer intentions to me. There is something poetic and tragic and grandiose about only letting songbirds eat from you and destroying anything else that tries.

✳ The Lone Cypress. A North American celebrity that has stood alone in Pebble Beach, California, for more than two hundred years. Overlooking Carmel Bay. She might have longed to succumb to the ocean, to fire, countless times, but people have stepped in and said, *No, please. Not yet.* Added structures and reinforcements, begging it to remain an icon. *Please stay and remain an icon.*

A LIST OF THINGS I WISH I COULD EXPERIENCE

✳ I want to know how it feels to be tall grass in the wind, fearless in a storm, storing rainwater deeply.

✳ I want to know how it feels to be ceramics, glazed and fired. My skin infused with glass, gleaming equally with fragility and strength.

✳ I want to know how it feels to be a building overtaken by ivy. To succumb to roots and leaves over time. Crumbling as I'm eaten alive *slowly, slowly, slowly*.

✳ I want to know how it feels to be a tombstone that has been read for the first time in a long while. Would the ghost know? Be grateful?

✳ I want to know how it feels to be a dewdrop running down a blade of grass until it meets another and merges with it. I am so jealous that water can experience that cohesion and I cannot.

✳ I want to know how it feels to be a plant photosynthesizing. I always feel that the sun is feeding me, until I stand and realize how weak it has left me.

✳ I want to know how it feels to be a pebble in a river. How long it would take for the current to move me, for erosion to do its job. To not be responsible for anything.

✳ I want to know how it feels to be lightning, an unapologetic show-off. To carve out veins in the night sky, to strike through the heavens as electric plasma. The power, the force. Does it know it inspires awe and induces fear?

✳ I want to know how it feels to be a lush, unkempt field. I want to be soft and move with the wind. To protect and hide those I love without any fear.

✳ I want to know how it feels to be a bird sweeping over an entire city, unabashedly witnessing how people live in every building and apartment, what they cook for dinner, how they sleep at night, what they hang like trophies on their walls, who they dream of and what they mourn.

GENTLE CHAOS

FOR THE ARTISTS

here was a period when I stopped painting. It wasn't a conscious choice, just the result of a series of reasons. General artist's block. I had just finished art school and I was so drained. I had started my first full-time nine-to-five job, and I wasn't feeling inspired. I simply had no big ideas.

I had just finished creating a huge thesis and body of work in which I developed an alter ego, a glowing pink alien named Valentine who defied gender norms. The paintings were loud and electric; they took secret experiences and stories from my life and transformed them into large, theatrical narrative paintings that gave my alter ego space to step in and speak for me when I was still too quiet and shy to speak for myself.

How was I going to top that? What would be my next big "move" as an artist? For almost four years, I didn't have the answers to those questions, and so I didn't paint. I was even teaching community art classes during this time. I would occasionally come up with an example art piece for my students, but that was the closest I ever got. When it comes to creating, the longer you spend away from it, the more impossible it seems to return to it. There was even a moment when I thought,

Maybe I'm just not an artist anymore. Maybe I have nothing left to give.

It was during this time that I began to take content creation and posting silly videos on the internet very seriously. It became a joyful creative outlet for me, but at the same time, I wouldn't call the videos I was making art. When I looked through my old art school photos and the portfolio that was tucked under my bed, I felt like I had lost a friend. I could hear my professor's voice in my head ringing out: *Every day you have to paint. Whatever life throws at you, you have to wake up and paint.*

After JiaHao and I relocated to California, after I had dug my heels into the sands of self-employment and kept my head above the water, I decided to take a couple of weeks off for myself. On one of those days, I was sitting alone in the living room and suddenly it struck me hard, almost like lightning to the head. *I wanted to paint.* I dug through our boxes and closets, I found some tiny secondhand canvases and my painting supplies, and for four days I painted, working off a photo from our trip to China. It was taken near JiaHao's grandparents' neighborhood. A photo of an old, crumbling public toilet in the middle of a field, filled with heaps of branches and twigs to prevent people from overlooking it and falling in.

It was as if I hadn't taken four years off at all. The painting felt right. It made me happy, and looking at it now still makes me happy. That's all it is for me. When I look at it, I remember that afternoon in China. JiaHao showing me the neighborhood he grew up in and played in, the old stone well in his grandparents' backyard that he would stare down and spit in. Me marveling at

these beautiful, decimated, moss-covered structures not realizing they were toilets. It was all funny and quiet and just nice. And I also remember the feeling of finally picking up a brush again.

I ordered more paints and brushes as a Christmas gift for myself. I sat and scrolled through my phone. After a year of being inside, I was looking through old travel photos and memories for inspiration but also for joy.

For my next painting, I chose this dinner we had in China. We took the bullet train from JiaHao's hometown with our friends to spend a few days in Hangzhou, which might be my favorite city in China. JiaHao was helping me look through the menu for something I could eat as a vegetarian. There were days when we struggled to find options, but I happily ate sauteed cauliflower and rice, peanuts and fried dough. At this restaurant, though, they had a rose and mango pizza and mushroom soup. The pizza had this beautiful, vibrant magenta rose syrup sauce instead of marinara, diced mango and cherry tomatoes, and cheese, and that was it. It was served beautifully on a bed of chili crisp strings and rose petals. When I looked at that photo, I thought so longingly of how nice it is sitting around a table with friends and trying new foods on vacation. Something I will never take for granted again. So I spent a few days painting that pizza. How amazing it felt to paint pizza!

I wasn't creating the huge, theatrical, and queer paintings that I had hoped my brain would come up with, and that was okay. I was just creating for the sake of comfort. For the sake of creation. Which was somehow an option that I had forgotten was even available. I love these little paintings, but at the time of

GENTLE CHAOS

creating them I was dismissive of their value. *These aren't real paintings. These are just for fun.* I have a lifelong problem of downplaying anything I create or am passionate about as "just a silly little thing." Maybe if I don't show how much I value something, I can't be hurt by someone else's opinion of it.

Not caring is a defense mechanism. *I'm only making silly little paintings right now. I post silly little videos on the internet.* But it turns out things are allowed to be both silly and important. The act of painting and creating is, in itself, magical to me. Regardless of the method or subject, it's self-expression. And art contains multitudes! I can have a cute and silly picture of a rose and mango pizza hanging in my kitchen. It can also represent a period in my life when I was incredibly isolated and lonely and scared, and I wanted to take a simple and beautiful memory of food, friendship, travel, and my partner and immortalize it forever in paint. Not to mention the rich history of food in art and the countless ways it can be represented and interpreted. Maybe I could pull and learn from that, become a part of that conversation, even. The possibilities are truly limitless.

This is what I'd like to stress more than anything to all of the artists out there:

You will always be an artist.

Art is so much more than the amount of time you spend putting paint to canvas, or pen to paper. It's your identity. It is more than a linear timeline. It's how you see the world, its shapes and colors, and no amount of time spent away from creating is ever going to change that. Inspiration comes in many different forms, and you may not be making art right now. When

you do make art again, it may not be the art you thought you would be making, and that is more than okay! In fact, it can be a beautiful thing.

Over the past couple of years now, I've made a whole series of little paintings based on sweet memories that I cherish. I'm thrilled if other people enjoy them, but ultimately they are talismans for me and me alone. They are hung up next to my bed, in our living room, in the kitchen. And when I look at them, I think of the fond times they depict, of how time has passed since then. They remind me of how I have changed since then, and I think about how much more the moments mean to me now that I've given myself the space and time to sit, process, and dissect them—their lighting, their forms, their textures and lines.

I do not know what I will create next. Or what the future holds. I do know that I will always be an artist. ૭ᷓ

APARTMENT

Written on paper
and set ablaze
I carried the memory
of our names in my pocket
wrapped in tissue.

Up the hills,
I spoke ash onto the house
built on mountains
under cypress and stone.

I might be a witch.
Overlooking freeways
and little houses
with tiny lights
secluded but with
little privacy

How strange to sit still
after years of running
as fires loomed in the distance
as colossal palms
and giants
fell.

As stars rose,
And stars slept,
over Malibu,
under Sunset.
As stars screamed
in the night—
Hollywood Forever

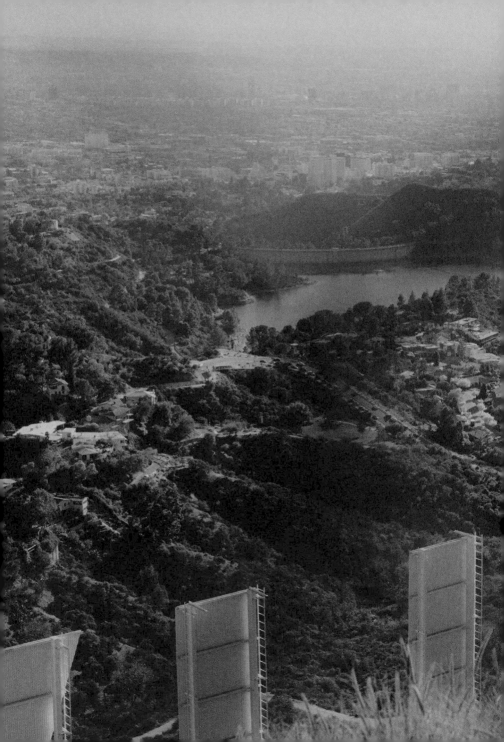

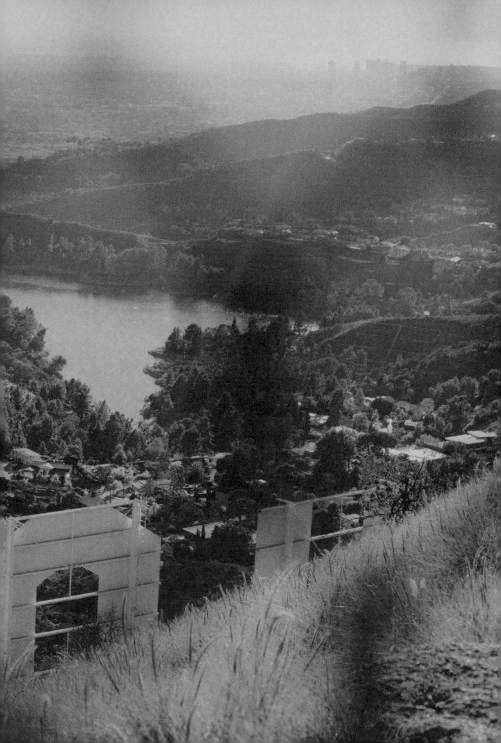

part 5

CURTAIN CALL

WISTERIA

I wish my bones were hollow
like the ravens in LA
on the cypress
on the wires
speaking secrets
to each other

I am not smart
Not good
Not big enough
to understand

how I wish
The storm cloud men
could stay,
stay a little longer

But all they know
Is to roll
along like thunder

They'll never release me.

In the summer
they're the hot wisteria
Gripping
Petals melting
down the back of my neck.

They'll never see beauty

in silver stars,
late night succulents
cast in a car's
crimson light

I would crown the head
of any man who stopped
and noticed
the star-shaped freckles
That kiss my shoulders.

They are bigger than me
Bigger than violent sun
or violet moon.
Beaming down upon my head
I never knew rest
on that small double bed

stumbling out of the attic
I willed the lines
on my palms to change
But in some ways
I still feel seventeen.

I cannot sleep
I cannot rest
till I know
If you like me best.

You are so brave

just like me

I can tell

I think

we are both

going to be fine

FORTUNE TELLER

never have I ever

been able to look

farther ahead

than my own hands

In front of

my star-seeking eyes

I only know

looking back

The future for me

has always been

less than

blue mountain fog

less than

green knees and VHS haze

Rarely have I

walked into the new day

or into the sun

with confidence and grace

I have only ever

stumbled forward

hands searching

with both eyes

on the day before

LAST NIGHT

I ascended
through leagues of dark water and sky
And dreamed
that with my back to the earth
My feet to the setting sun on the horizon
I rose up to heaven

I awoke to strong thunder in LA
That rang and shook the breath in my chest
How many times have I woken to storms?
Only to have them sing me to sleep

Sometimes I think
I truly wouldn't mind
Being a jellyfish.

Maybe I'll be rewarded in my next life
if I am good

To have no ego at all
even with the potential of immortality.
Unburdened by thought
toxic but not cruel
As delicate as water itself
A gift from the moon herself

THERE ARE NO
MORE DINOSAURS

When I was younger, there was nothing I feared more than death. I remember the night that I first became aware of it, watching a movie about dinosaurs. As they migrated through drought and intense heat, one of them collapsed in exhaustion and died, its child roaring alongside it. And then it struck me. There are no more dinosaurs. I ran to my mom sobbing. Would I one day collapse too in exhaustion? Would she? Would we all?

I have this recurring nightmare that's haunted me my whole life. The location is different for every dream, but they are all very dark. I wander through the halls of my childhood homes, cabins I've never visited, hotels and boats—and I struggle to turn on a light. Every time I come across a sconce or light fixture, there is a flicker of hope inside of me, and when I stretch my hand to turn the switch, the fixture turns on. But its light does not fill the room. It is almost as if the light is trapped within the bulb. It glows dimly, emanating maybe an inch off the surface of the glass, but it does not permeate the darkness that meets it hungrily. I move through these structures, turning on every light I can find, and when I am done, it is just as dark as it was before I began.

Is this death? Is this what ghosts experience? Frantically moving through locations both strange and familiar, hoping to illuminate the space to feel comfort and safety, but stuck forever in an inky darkness that swallows everything around you, including yourself?

It simply cannot be.

I don't know what awaits us on the other side of the big sleep, and I am not even certain what I believe anymore. But it no longer scares me the way it once did. How could the other side be full of anything but love? I know one day my body will break down, return to the earth, like the dinosaurs before me. The energy I use to keep my heart beating and my eyes seeing will be transferred through the wind to plants and birds. But what will happen to my love? For my family and friends, for clouds and the moon, for magic and animals? I think that what I put my faith in, what I long for, what I believe in more than anything, is love. ☙

EAT ME

Oh please,
let wild deer feed from my grave
May the flowers you place
In memory of my name
May the feelings of joy
Of sadness, disgrace
Pity and shame
Be reclaimed
And consumed
By the grand forest game

IN THE NIGHT

My own hands
copper wires running through
electric and blue—
they float slowly across my chest
until, with an ironclad grip
upon my own shoulders,
I send myself away to sleep
To sleep
To sleep

The moon,
my moon,
she knows no one else
Quite like me
in those slowed-down moments of longing

No matter my age.
No matter the day.
Through wild tempests
that pacify my sun,
through ice and wind
that leak in through
the bones of me and my house,
On nights full of hot thunder,
Crickets, smoke and laughter

always electric
always blue
even when someone's holding me
it's my own fingers
upon my own shoulders
that cast me
to sleep
to sleep

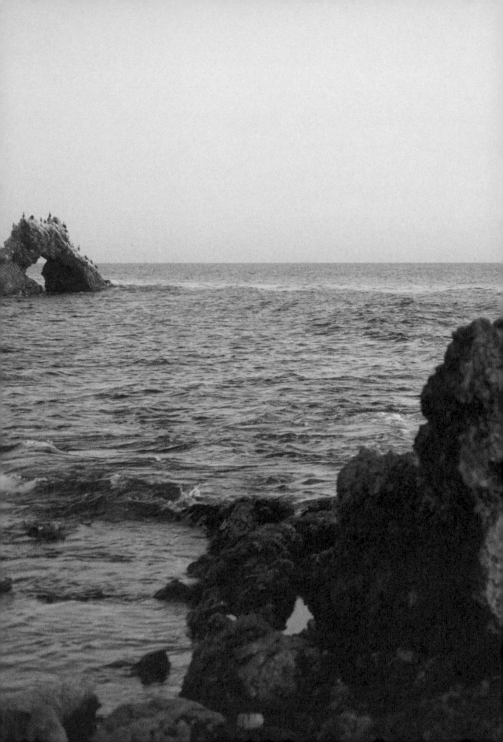

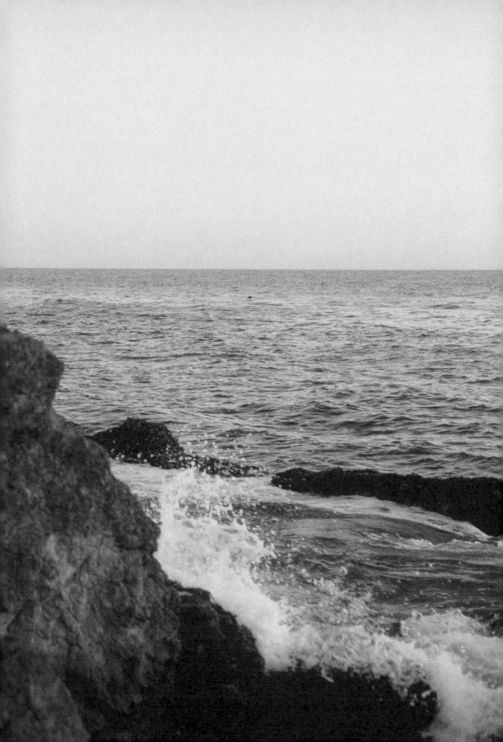

Too often

have I planned every word

Every pause

and retort

Only to leave

with things unsaid

GENTLE CHAOS

YOU ARE THE SUN

In the morning
All that I
and the earth
Have yearned for

Gilding the horizon
Your joy moves through all
and I am the moon
So loud in my silence
in the night
Alone with only
The ghost of your heat
On my skin

But even with space and stars

And atmosphere
between us
I shine
Only when your light is on me

MAN OF MIST

Deep in the forest
between viridian branches
Which bow down to the ground
heavy with pine needles

the clouds move low
like smoke
or ghost fire
Billowing
and rolling
their shoulders and arms
through the leaves and tree trunks
leaving only dewdrops
that cling to and claim
all the earth
and its creations

Cutting through the mist
two orbs
of glistening golden light
Trying their best
To stretch and shimmer
through the fog
like the old gas lanterns
they emanate from

Twin guards
Who keep none out
And invite all across
the cobblestone bridge
where they dance on both sides.

The moon overhead
is radiant, full,
Every light is her child.
Every twinkling star in the sky
even the quietest
forgotten flicker of flame
Dances in a cobweb-filled vitrine
for their mother in the sky.

The babbling brook
that flows beneath
might as well become one
with the clouds that roll over it.

Who are we
to distinguish
What is water and what is air?

Who are we
to call out to the man
Made of mist himself?

The man who walks
Only for his boots to make no sound.
No crunch over gravel
No swish from his coat

Even the twin lights
which draw him ever closer
Which yearn to cast themselves
Over the peaks of his face
Only burn and blur out his image

He is vapor in a glass,
Nothing more
Than routine and repetition
carved out
through history
space and time

over and over again,
he reaches the bridge's crest
and comes to a stop.
Retrieving a small pebble
made of haze
from his pocket
he reaches over the edge of the bridge

and lets go.

The pebble falls
with normal speed
but seems to dissipate
as it touches the stream's surface.
Forming and flowing
into the low, sweeping clouds
that press themselves
against the waters.

The man of mist moves on,
walking to the other end of the bridge
And like the pebble before him
he dissolves
like ink into water,
his haze mingling
with the thousands
of tiny water droplets
that blow through the wind
and catch on
the pine needles and leaves.

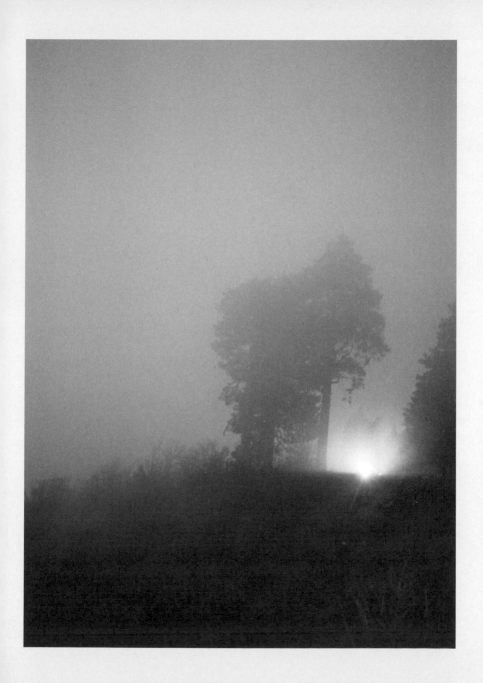

BABY BLANKET

he safest I ever felt was when I was five years old at my sister's soccer game. It was held outside on a massive field nestled between rolling hills that I would run up and tumble down. To this game I brought a blanket my aunt had made when I was a baby. The underside is a soft, navy blue fabric covered in tiny white stars, and the top is a patchwork of red and blue plaids, flowers, and stars.

On this occasion, I was playing a game with my dad. He would bundle me up inside the blanket and lift me into the air. I laughed and laughed inside the bundle. I could feel that I was off the ground, but all I could see from inside the blanket was the sun beaming through the fabric, blending the patchwork design on one side with the sea of white stars that enveloped me. I felt so small inside that blanket, and for those moments, the rest of the world disappeared.

This next part might sound morbid, but I hope that death is the same. When the time comes, I would like to be 103 years old, and I'd like to feel small but safe and full of childlike joy and wonder, enveloped in a sea of navy blue with twinkling white stars, the sun beaming through onto me. ᏣᎦ

MARY VIRGINIA

My great-grandmother
Her memories warm
I took her hand
led her up the steps to my bedroom
On the day of my birthday
To show her my toys
I don't remember her voice
But I remember her hand in mine
On that day
Five years later I saw her again
And when we said goodbye
even at ten I thought

This could be the last time
I think I can paint
Because she and my mother
Were so close
I like to think
It would have pleased her to see
What I grew up to be
Mary Virginia
Oklahoma
Rests with Gene

Raw Apple Cake (Doris - cousin)
Virginia Duggan

2 cups sugar	½ tsp. salt
1 cup oil	3 eggs
3 cups flour	1 cup nuts
½ tsp. soda	3 cups fresh
1 tsp. vanilla	apple Chunks

Mix sugar and oil. Add eggs one at a time and beat after each addition. Sift dry ingredients together. Add to oil and sugar mixture. Combine thoroughly, but do not beat too much. Fold 'in apples and nuts. Bake in greased and floured bundt pan - 350° - 1 hour.

Brown Sugar Icing

½ cup brown sugar 1 tsp flavoring
¼ cup milk or cream 1 TBS. butter

Heat these ingredients to a boil. Add sifted powdered sugar (about 3/4 cup). Drizzle over top of cooled cake.

sometimes I wish
so badly

I could photosynthesize

that every autumn
I could wither away

come back every spring

new and untouched.

GENTLE CHAOS

→ there is magic here ←

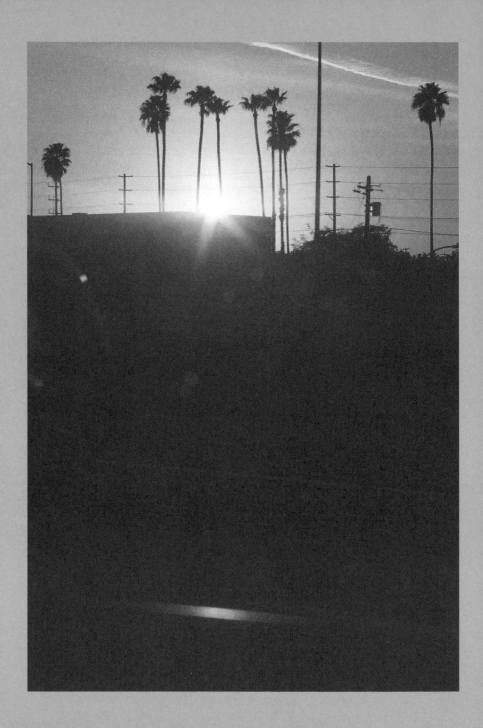

There is magic here.
In the sun behind palms in LA
The first time I drove into Los Angeles
I thought to myself the palm trees looked fake
They stood too tall and too narrow
How could the wind not bring them down?
During earthquakes did they wiggle and wave?
Did the fronds turn and drop in the autumn?
How long do they live for?
How would they look if their stalks were invisible?
Like great emerald fireworks suspended in time?

It wasn't until much later that I learned
That the palms were planted by the tens of thousands
In the nineteenth and twentieth centuries.
To enchant visitors
To create fantasy
They were once outsiders in this city too
Now they have become part of its landscape forever
Is it too greedy, or even possible, for me, for anyone,
 to do the same?

There is magic here.
In the queen of the night
Who blooms only for the moon
Late into the velvety darkness
Whose sweet and delicate petals
can be brewed and consumed
Allowing you in a way—
to ingest the moon itself

There is magic here.
In the veins of every plant
running under every fern
and throughout the forest floor.
There is magic in my camera
that caught this moment in time,
magic in the light
that slithered in
and burned my film
to let me know
that it was there too
in that moment.

There is magic here.
In these bricks that have shifted
Over time.
There is romance here
in this couple being brought together
by time or weather or a guiding hand.
Forever leaning on each other
As snow melts
As flower petals fall around them,
and blanket them,
Frame them and their love.
Cheers to the beautiful couple

There is magic here.
In roots that have grown so wild
And formed as one
Created homes
And networks
And whisper to each other
Late into the night

There is magic here.
To stand alone in a cave
To see waves reach and stretch
And collapse exhausted
Into seafoam at your feet
There is magic in the rocks,
In the salt water calling out
To the water inside you

There is magic here.

In the yellow angel trumpet

To have a name that calls to heaven

But to be a flower that can summon death

To be just as fragrant and alluring

As you are toxic

To bloom with your back to the sun

But still adopt its glimmer

That is dark magic

if ever I've known her

There is magic here.
When the world shut down
I savored every walk
I moved through the streets
For miles, for hours

Taking the time
For maybe the first time in my life
To memorize street names
Document every flower
Every garden lantern and gate

On one cold day
my camera almost gave up on me
I held her close to my chest
Tried to breathe life and warmth into her

And snapped this one photo

Of this chocolate rabbit making
His slow revolution
There was so much beauty
In a time of uncertainty
The dazzling lights
The cold, blue midwestern sky
A window display
for a neighborhood
For me

Even though the store stood closed,
To offer something up
With no expectation of a gift in return
May be the most magical thing you can do

there is magic here

in every leaf
in the light
that burns
my eyes
and my film

I AM THE
LOVE WITCH

Sometimes I worry
that my heart is too big
Not in the sense that I care
 too much
But in the sense
that it wants more
than I can ever give it

Am I greedy?

Driven by my heart
To ask for more every time
My heart is ravenous
And there is no such thing
as too much

Even when it is weeping

Especially when it is weeping

To all who cross it
Beware my weeping heart

I am the love witch

GENTLE CHAOS

I think there is something to say
About those who worry so frequently
That they are not good

How could you truly be good
If you were not challenging
The state of your goodness
Every once in a while?

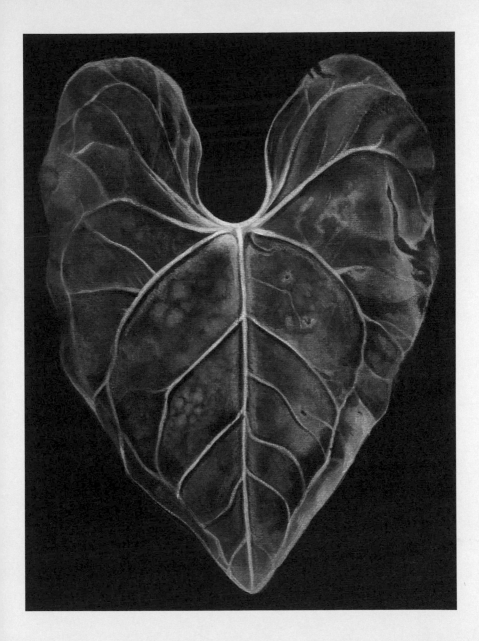

SHOULD I EVER DIE

let me be a tree.
Stand me up
a tall man forever.
Apart from the others,
until jade seas
should swallow
my weeping willow branches.

Should I ever be
surrounded by sweet pea
alone in the night.
Caught whispering
through the wind—
to snapdragons,
dragonflies,
wild clover,
my lover
the moon.

May I stand
A beacon
to lost ships
to lost souls
a tall man forever
my very own
Garden of Legends.

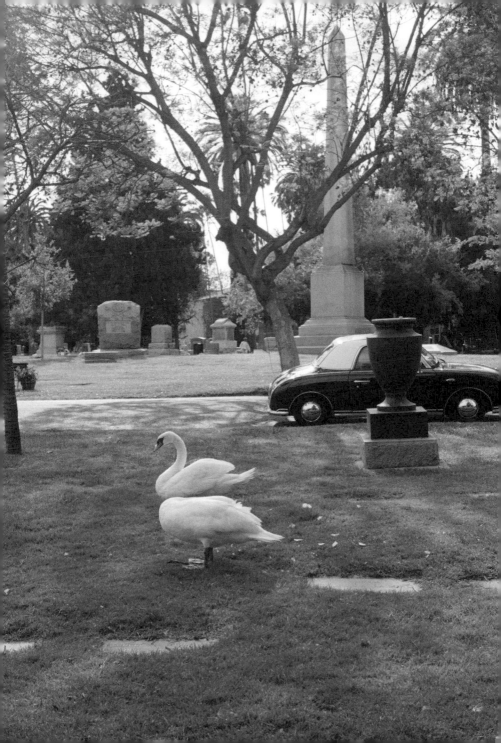

GENTLE CHAOS

One day I will be gone
One day this page will be gone
One day someone else will read this
One day they will be gone too

One day we'll all be together
One day we'll all become one

How privileged I feel to take the moments
That are so small and so beautiful
So mundane and significant
So quiet and ephemeral
And make them big
within this small book

How magic it is
to make something personal
Into something communal
In hopes that it will help.
In hopes that it will find its way
To someone who needs it

To share yourself with the world
is just as sad as it is sweet

Is just as much a relief as it is a burden

this to me, and me alone
Is delicious and sacred

This is gentle chaos

this is gentle chaos

xx ghosthoney

Acknowledgments

Thank you so much to everyone who helped bring this book to life. Thank you to my parents for always supporting me even when they didn't fully understand me. Thank you to my older sisters, Lauren and Nellie, for helping raise me. My nieces and nephew—Landry, Colbie, Raegan, and Joanna. I love being your uncle. To JiaHao, for loving me and supporting me since day one. Thank you to my witch sisters, Jenni and Tanya, for cheering me on so ferociously. Thank you to my gay boys for being the brothers I never had. Thank you to my managers, Barbara and Mark, for championing me, and to my literary agent, Seth, for reaching out and telling me in that first meeting that what I was doing was important and more than just making silly videos. A big thank-you to Shannon, Jenna, and everyone at Running Press for being so excited to work with me and being such amazing collaborators. Thank you for believing in the vision I had for this book and not being scared away when I sent over a PDF that had a scan of human teeth in it. A big thank-you to all my followers for believing in me, for treating me like a friend and caring about my ideas and what I have to say. I hope you love this book, and I hope I made you all proud.

About the Author

TYLER GACA is an artist currently living in Los Angeles with his husband, a menagerie of animals, and many plants. In 2019, he began posting comedic videos to social media under the name Ghosthoney, and he has since built a career out of his surreal and offbeat sense of humor and his love and fascination for all things magical and morbid.